T0285786

GOING UNDERGROUND EDINBURGH

JAN-ANDREW HENDERSON

AMBERLEY

ACKNOWLEDGEMENTS

Photographs by Jan-Andrew Henderson and Jamie Corstorphine.
Pictures of Mary King's Close courtesy of The Real Mary King's Close.
Pictures of Marlin's Wynd courtesy of the Rowan family.
Drawing of proposed George IV Bridge development courtesy of Allan Murray Architects Ltd.
Pictures of the South Bridge Vaults courtesy of City of the Dead Tours.

First published 2022

Amberley Publishing, The Hill, Stroud
Gloucestershire GL5 4EP

www.amberley-books.com

British Library Cataloguing in Publication Data.
A catalogue record for this book is available from the British Library.

ISBN 978 1 3981 0628 4 (print)
ISBN 978 1 3981 0629 1 (ebook)

Typesetting by SJmagic DESIGN SERVICES, India.
Printed in the UK.

CONTENTS

INTRODUCTION

Edinburgh is a place of myth and lore, where separating truth from legend can be surprisingly difficult. It is the capital of Scotland – a nation often accused of having a large chip on its shoulder. So the inhabitants of this metropolis claim they don't just have bits that are underground. No. They have an entire 'Underground City'.

Is it true? Well, typically for Edinburgh, it does and it doesn't.

Certainly, there are plenty of subterranean pleasures to be found – with a rich history attached to each of them. What is surprising is how disparate they are. Put them all together and the result is pretty impressive. Jointly, they make up the legend of the Underground City.

This book is a collection of disparate things too. Firstly, it is a history of underground Edinburgh. What it is, who made it and the factual stories and weird legends attached to each part. Secondly, it is a guide to where everything is and how you can get to see it. It is also a pictorial account of what is down there, and what is above. So, thank goodness for the variety, as 100 pictures of identical tunnels would get pretty dull. Lastly, I've provided a handy ratings guide to what you can see and what I think are the most interesting attractions, including a supernatural rating (you'll be surprised how many ghost stories feature the Underground City).

I'll approach the subject in (very) roughly chronological order, though some parts are hard to date accurately. A combination of centuries of conflict and several large fires haven't done official records any favours. In fact, until fairly recently, most citizens didn't know that a lot of what is below them even existed and many thought the whole thing a fairy tale. There are parts that are gone forever and other sections you can't enter. However, a great deal is now accessible and, I promise, it's quite a journey.

So let's get our metaphorical flashlights out and go take a look.

Jan-Andrew Henderson

1

A SHORT HISTORY OF THE UNDERGROUND CITY

'Edinburgh is a sort of gothic fairytale city, and it can be a gothic
horror city as well.'

David Mackenzie

There has been some type of settlement on the site of Edinburgh since prehistoric times – and it is not hard to see why. Anyone who has witnessed the neck-straining splendour of Edinburgh Castle will testify that it is a superb defensive position.

In order to get a proper picture of underground Edinburgh, it is necessary to combine history and geography – to the horror of those of you who didn't enjoy either subject at school – but bear with me. We'll do it a bit at a time.

Edinburgh Castle.

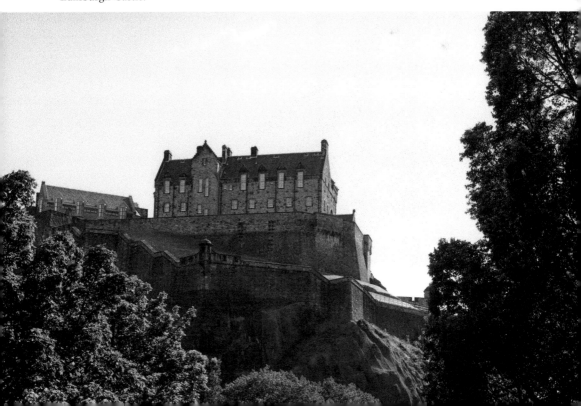

Castle Rock, in the centre of the Old Town, is where we begin – before humans ever set foot on the place. It is a volcanic plug of Dolerite, formed in the Carboniferous period, 340 million years ago, and towers over most of the city. It is part of an ancient volcanic complex (thankfully now extinct) that runs under Edinburgh – another of the outlet valves is the equally impressive Arthur's Seat. A long process of glaciation ground away the landscape around Castle Rock, causing sheer drops on three sides. On the eastern side, however, the land inclines gently down to the area known as Holyrood.

This is known as a crag-and-tail formation and was where the original town began, a rude collection of simple dwellings perched on the ridge. Castle Rock was the focal point of old Edinburgh and has held some sort of fortress since pre-Roman times. If invaders succeeded in taking the town, the defenders simply retreated to the fort and continued to fight.

But this high ridge of soft sandstone also gave Edinburgh a unique quality other cities simply did not have. One that was not considered by its citizens at first: you could dig into it.

In the early days, there was no need for anyone to live underground. A combination of natural hardship, invasions and the occasional deadly pestilence kept the population nice and low, so there was plenty of room for everyone. Houses spread eastwards from the castle in two rows, the area now known as the Royal Mile. At the back of these dwellings, steep inclines plunged to pastureland. The slopes were divided into sections called 'enclosures' and provided the settlement with crops and grass for common grazing. In later times, however, this pastoral idyll would completely disappear.

Royal Mile Ridge.

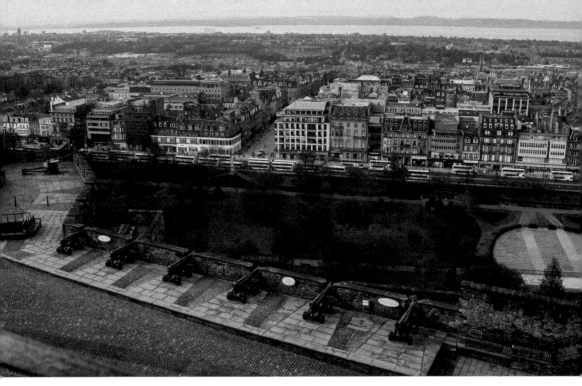

Above: View from Edinburgh Castle.

Below: Royal Mile.

Princes Street Gardens, formerly the Nor' Loch.

To the north, flat grazing land eventually became the Nor' Loch, now Princes Street Gardens. The south offered stable ground, though lower down, on which Edinburgh's Old Town expanded a little – the area known as the Grassmarket and Cowgate.

It was a precarious existence, for trouble was never very far away. The Romans invaded in the first century AD and took the place from a Celtic tribe they called the Votadini. They left in the fifth century to shore up a crumbling empire, and the settlement was regained by descendants of the Votadini, known as the Gododdin. They, in turn, succumbed to assault by Anglo-Saxon Northumbrians in the seventh century. In the tenth century, the Northumbrians retreated as well and Edinburgh came under the rule of the Scots. All this time, primitive dwellings were spreading down the Mile and, in the twelfth century, the Scots king, David I (1084–1153), established Edinburgh as one of the country's first royal burghs.

For several centuries, life on the early Mile seems to have been similar to the rest of Europe. The writer Froissart, visiting in 1384, called it the 'Paris of Scotland' and it seems to have remained a bustling but agreeable place until the fifteenth century. Well, as agreeable as a town riven with internal strife, possessing no sanitation, medicine or law enforcement and constantly fighting either the highlanders or the English, could manage.

FUN FACT
The street running down the Old Town ridge is called the Royal Mile because it was the route that royalty would take when travelling to the castle on top of the rock. To be fair, it was also the route everyone took – there was no other practical way in or out.

The Stuart Kings

Things started to get interesting in the fourteenth century, when Robert II (1316–90) came to power, the first of fourteen Stuart (later called Stewart) kings. From then on, the fate of this dynasty would be inextricably linked with that of Edinburgh, which wasn't always a good thing for either.

Robert II and Robert III (1337–1406) set the pattern for this love/hate relationship between Scotland's capital and its Stuart monarchs. Both were feeble rulers and allowed the southern Scots nobles to do pretty much what they liked, which was generally bleed the peasants dry, rebel against the crown and periodically invade England, who would then retaliate. The result was centuries of bloodshed, with the Royal Mile at its centre.

Before he died, sickly Robert III sent his heir to France in order to escape the clutches of unruly nobles. Unfortunately, the future James I (1394–1437) was captured by the English en route and held to ransom for seventeen years. When it became apparent the Scottish aristocracy had no intention of ever paying up, the English let him go.

James returned to Edinburgh in 1420 with big ideas for ruling his country, but the nobles, who had gotten used to doing what they liked, weren't going to put up with that kind of interference and eventually murdered him. James II (1430–60) came to power at six years old and spent years throwing off the yoke of his powerful barons. As part and parcel of these turbulent times, Edinburgh began to give some serious thought to strengthening its defences.

FUN FACT
Ironically, James II was killed putting down a revolt by his nobles. At the siege of Roxburgh Castle, he was blown up by one of his own cannons.

2

THE KING'S WALL

To the north of Edinburgh lay the marshy Nor' Loch, formed in the early fifteenth century by building a dam to block a local burn – the appropriately titled 'Stank'. The resultant lake was totally unsuitable for drinking and used as a convenient rubbish dump, but it was handy for keeping potential invaders at bay. Edinburgh Castle defended the western approach, so walls were only thought necessary on the south and east sides of the town.

The King's Wall was first recorded in 1427 and King James II then issued a charter permitting the burgesses of Edinburgh to further defend their town. The original charter is in broad Scots and difficult to read, so here's a rough translation:

> Inasmuch as we are informed by our well-beloved Provost and Community of Edinburgh, that they dread the evil and injury of our enemies of England, we have in favour of them, and for the zeal and affection that we have for the Provost and Community of our said Burgh, and for the common profit, granted to them full licence and leave to fosse, bulwark, wall, tower, turret, and other ways to strengthen our said Burgh in what manner of ways or degree that be seen most speedful to them. Given under our Great Seal at Stirling the last day of April, and of our reign the thirteenth year, anno 1450.

Rather wordy by today's standards, but the intention was clear enough: get building.

The Kings Wall ran along the south side of the Royal Mile above the Cowgate, from the slope of the Castle Hill in the west, almost as far as St Mary's Street in the east, where it turned to cross the Royal Mile. It enclosed a space less than half a square mile and incorporated existing buildings, which were reinforced rather than being knocked down. The early wall had two ports or entrances: the Upper Bow (now Victoria Street) and the Nether Bow, on the Mile itself, near Fountain Close.

In 1472, King James III (1451–88) finally ordered the demolition of houses built on or outside the King's Wall, as they were hampering efforts to properly strengthen the defences. Not that it did him much good. James III was so unpopular, his own son (another James) joined a mutiny that saw his father killed in battle. That's teenage rebellion on an epic scale.

Interest Rating 2/5 (much of the wall is gone or incorporated into the Flodden Wall)

3

THE FLODDEN WALL

James IV (1473–1513) seemed cut from a different cloth to his forefathers. A charming and intelligent man, Edinburgh seemed set to flourish under his rule. Then, he threw it all away and inadvertently set the conditions under which an 'Underground City' would be made.

In 1513, he led the largest force the Scots ever amassed, an estimated 60,000 troops, and marched into England. This was in retaliation for King Henry VIII's invasion of France for the Scots and French had a treaty (the famed Auld Alliance) to deter England from invading either country. It was a pointless battle, fought for an ungrateful ally, and became Scotland's greatest military disaster.

The English army was led by the seventy-year-old Earl of Surrey, a battle-hardened veteran. Though he had less than half the numbers of the Scots, he actually knew what he was doing. The Scots charged, having taken off their shoes to get a better grip on the slippery ground. They were armed with the traditional 16-foot 'pike', but the English had a new weapon: the 'halberd' or bill – a combination of spear and axe. One chop with a halberd and the Scots found their 16-foot pikes were 8-foot pikes. Then 4-foot pikes. Eventually, they were fighting with toothpicks.

James IV, leading the centre battalion, is supposed to have fought within a spear's length of the English commander before he was killed.

Flodden wasn't so much a defeat as an eradication. Accounts of how many Scottish lives were lost are between 10,000 and 17,000 men, including James and a large proportion of his nobility.

The death of the king caused panic in Edinburgh. Since pretty much the entire Scots army was wiped out, nobody was left to defend the city from counter-invasion. Weaponry, especially cannons, had greatly improved and the old walls were no longer adequate for keeping the English at bay. The inhabitants of the Cowgate – a new and aristocratic suburb next to the Grassmarket – were particularly horrified, since they were completely outside the narrow city defences.

Edinburgh's dignitaries resolved to build a new town wall, extended to take in the Grassmarket and Cowgate areas. Construction began the following year but was not completed until 1560, so it's a good job the English didn't counterattack after all. Legend has it that twenty-four of the town's strongest men were recruited to keep watch and alert the builders to any approaching force. The rest of the population toiled with swords lying within arm's reach.

You may want to use Google Maps for the next bit.

The Flodden Wall was around 1.2 metres thick and up to 7.3 metres high. It began at the south side of the castle, running south across the west end of the Grassmarket, where the

West Port was located, and continued uphill along the Vennel. A watchtower still survives at the south-west extent of the wall. It then ran east, around Greyfriars Kirkyard, to what is now Bristo Square and Potterow. Continuing east, the wall passed the Kirk o' Field, where the Old College now stands, and ran along Drummond Street, veering north at the Pleasance to enclose the former Blackfriars Monastery. Here another entrance was built – the Cowgate Port – at the foot of the Pleasance. The wall then ran up the line of St Mary's Street and joined existing fortifications, leading to the Netherbow Port on the Royal Mile. It then continued north to the Nor' Loch. To drive home the point that Edinburgh wasn't to be messed with, heads and limbs of executed criminals were regularly displayed above the ports.

In the end, it was a lot of work for little gain. The wall was not particularly effective, as a few examples will show.

In 1544, an English force, under the command of Sir Christopher Morris, blew open the Netherbow Port with their artillery. The town was razed over the following three days and according to accounts 'neither within the walls nor in the suburbs was left any one house unburnt'.

In 1558, the Protestant Lords of the Congregation marched on Edinburgh against the Catholic Regent, Mary of Guise. They were able to take control of the town without difficulty.

Below, opposite and overleaf: The Flodden Wall.

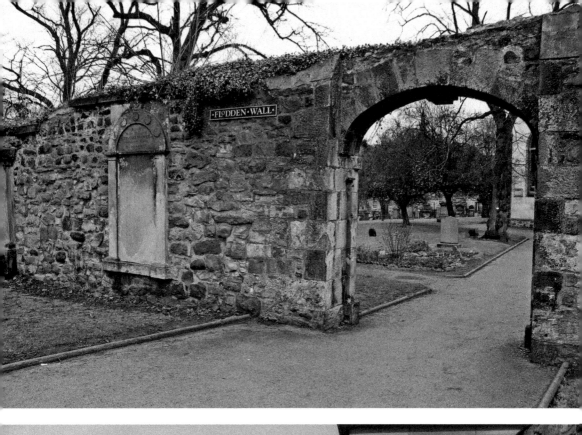

The most famous story of the wall's failures was the taking of Edinburgh in 1745 by Charles Edward Stewart (1720–88). It's probably a myth, but his men are supposed to have gotten through the Netherbow Port by parking a cart in the entrance, so the gates couldn't be closed. True or not, 'Bonny Prince Charlie' captured the city without any real resistance.

What the wall did do was finish the job of completely enclosing Edinburgh – for an astonishing 250 years, scarcely a house rose outside the barricade. The walls were

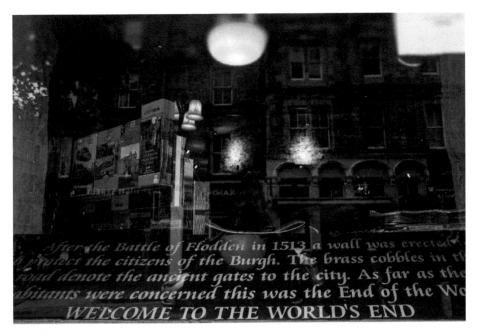

After the Battle of Flodden in 1513 a wall was erected to protect the citizens of the Burgh. The brass cobbles in the road denote the ancient gates to the city. As far as the inhabitants were concerned this was the End of the World

WELCOME TO THE WORLD'S END

The World's End pub window.

added to and strengthened whenever it looked like the English army might fancy another foray north, but the defences were never much more than a mile long and a quarter of a mile wide.

This is not a large area. And the whole of Edinburgh's population was stuck inside.

FUN FACT
The Canongate, leading down the lower Mile to Holyrood, was left completely undefended and there is a reminder of that to this day. Where the Netherbow Port stood is the World's End pub. No prizes for guessing the origin of the name.

Interest Rating 4/5

4

THE HIGH STREET OR UPPER ROYAL MILE

'Protocol Books' by city notaries show that building control in the old days was pretty much non-existent. In 1500, Protocol books by John Fowler showed the ground within the wall rapidly becoming covered in tall buildings. These were known as 'lands' (now more commonly called 'tenements') and grew to an astonishing ten or eleven stories. One block in Parliament Square reached the dizzy height of fourteen stories.

Every spare foot of space had to be utilised and houses reached 130 feet high. They were the first skyscrapers in the world and as tall as city architects dared erect them. The Flodden Wall remained the limit of the burgh until the eighteenth century and, contained within this tiny area, was a population of around 10,000.

Grassy enclosures vanished under a rash of tenements and the passages between them narrowed until they were only a few feet wide. The term 'enclosure was shortened to 'close' and now meant exactly that – everything was crammed together.

There was no place left for the population to go. Except down.

Since space was at a premium, advantage was taken of the soft sandstone underfoot. As the buildings of Old Edinburgh stretched upwards, the foundations got deeper and countless cellars were created. The steep slopes on either side of the High Street meant that these cellars didn't necessarily have to be excavated from above. Builders could dig sideways into the ridge, allowing underground levels to be built at a depth that would not have been possible in any other location. Though open at one end, the further into the hillside they went, the further under the buildings they got. Because of the steepness of the sides of the upper tail, cellars could also be built one above the other. Though these excavations were sideways rather than straight down, they were just as dark, wet and cold.

In the tenements, a strange social structure developed. There was no question of one part of the High Street becoming a wealthy or fashionable district – rich and poor were all lumped in with each other. In the end, the class system prevailed, as it usually does, and the buildings themselves became divided according to social strata. A single tenement in Dixon's close is a good example. On the ground floor was a fishmonger, on the first floor a lodging housekeeper, on the second floor the Dowager Countess of Balcarres, and on the third floor Mrs Buchan of Kelloe. The floors above this contained milliners and mantua-makers (dressmakers) and the garrets or attics were filled with tailors and every other type of tradesmen.

Of course, if you were really poor, you ended up in the cellars underneath.

In 1822, William Hazlitt called the Old Town 'a City of palaces, or of tombs – a quarry, rather than the habitation of men' and Robert Louis Stevenson (1850–94) described it

Above and below: Buildings on the Old Town ridge.

Stairs leading up to the Old Town.

as 'for all the world like a rabbit warren, not only by the number of its dwellers but the complication of its passage and holes'.

It is hard to imagine the horrific conditions that existed in these underground chambers. In winter, Edinburgh is wet, freezing and windy. Within the bare walls of these frosty cellars, conditions must have been arctic. Lighting fires warmed the inhabitants but filled the cellars with acrid smoke and represented a huge safety hazard – for there were tons of timber directly over them.

The threat of fire was a constant worry to city officials, though the underground vaults were actually a safer place to light fires than the wooden houses above. In 1666, a town council edict proclaimed a fine of a hundred merks for anyone found baking bread in 'any high or loftit houses' instead of 'laich cellars or voltis upon the ground'. Underground inhabitants must have breathed a sigh of relief at this. Burning tenements tended to collapse, burying the cellar occupants.

But, if winter was bad, summertime conditions were worse.

Edinburgh had no sewage system. The method of garbage disposal in the Old Town was to shout 'Gardy-loo' and throw everything out the window. Gardy-loo was a warped version of Gardez L'eau (approximately French for 'watch out for the water') – except it wasn't just water the warning referred to. Effluence, sewage, dead cats, or anything else you didn't want in the house went out the window. If you lived in the town, you knew about this and a cry of 'Gardez loo' was greeted by the return screech of 'Haud yer Haun' ('hold

your hand'). This would give you time to get into a doorway and all you suffered was a few splatters. In 1745 Edward Burt had a less than bird's-eye view of the horror of Edinburgh sewage.

> A guide was assigned to me, who went before me to prevent my Disgrace, crying all the Way, with a loud Voice, Hud your Haunde (hold your hand). The opening up of a sash, or otherwise opening a Window, made me tremble, while behind me, at some little Distance, fell the terrible Shower.

The High Street itself, perched on top of the ridge, enjoyed relatively tolerable conditions. To some extent, effluence drained off down the slope. Here, the cellars or 'laigh booths' were somewhat more habitable and even used by traders to sell their wares. Even so, residents sometimes had to cut channels through rubbish to get to their front doors.

And the liquid waste had to drain off somewhere. In the narrow closes behind the Mile, raw sewage was ankle-deep in the streets and the Nor' Loch slowly turned into a stinking, fetid sewer. Living at ground level in the back tenements must have been a truly harrowing experience.

If residing at ground level was wretched, living in stinking, diseased and rat-infested underground chambers, with sewage seeping in from above, was unbearable.

Yet people did bear it – there was no other place for them to go.

New levels were piled haphazardly on top of existing buildings and ground floor inhabitants found their dwellings becoming foundations for surrounding developments. Houses that had been open to the air were buried, becoming part of the growing Underground City. In 1775, Captain Edward Topham gave this account of the tenement structures.

> The style of the building here is much like the French: the houses, however, in general are higher, as some rise to twelve, and one particular to thirteen stories in height. But to the front of the street nine or ten stories is the common run; it is the back part of the edifice which, by being built on the slope of a hill, sinks to that amazing depth, so as to form the above number.

By the seventeenth and early eighteenth centuries, the Old Town was an architectural nightmare, earning the reputation of being the worst city in Europe to live in. And still, the people stayed. Outside the Flodden Wall was just too dangerous a place to be.

Interest Rating 5/5

That's enough history for now. Time to switch to geography and take a look at the places where you can discover some parts of subterranean Edinburgh. We'll begin at the top of the Royal Mile and move down the ridge, through the Lawnmarket and High Street. And the perfect site to start is the building that allowed for the creation of the city itself: Edinburgh Castle.

5

EDINBURGH CASTLE

Edinburgh Castle is the jewel in Scotland's architectural and historical crown – visible from all over the city, perched on a sheer rock face that would put off the most dogged attackers. Nobody knows for sure when the first fortification was erected, but it was certainly there before Roman times.

It became Scotland's chief royal castle in the Middle Ages and King David I (1084–1153) constructed some of the structures you can still see. A chapel dedicated to his mother, Queen Margaret (c. 1045–93), is the oldest building still standing in Edinburgh. The castle has seen action many times and, despite its forbidding visage, has frequently changed hands. Action during the Scottish Wars of Independence gives a flavour of this flux.

It was taken by Edward I of England (1239–1307) in 1296. It was then recovered by Sir Thomas Randolph, Earl of Moray, acting on behalf of Robert the Bruce (1274–1329)

Edinburgh Castle dungeons.

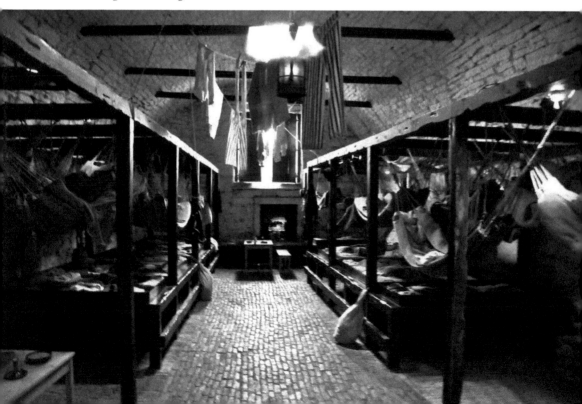

in 1314. His was a surprise attack, under cover of darkness, by thirty men who scaled the north cliffs. Twenty years later, it was recaptured by the English. Seven years after that, Sir William Douglas, a Scottish nobleman, got it back with another surprise attack using men disguised as merchants. About as effective as the Flodden wall, then.

The castle has been continuously added to through the centuries and is still a military garrison. Inside is the magnificent Scottish National War Memorial, the giant cannon called Mons Meg, the Crown Jewels (or Honours) of Scotland and the Stone of Destiny, on which Scottish kings were once crowned. With brilliant foresight, the famed writer Walter Scott (1771–1832) suggested it might make a good tourist attraction someday. As usual, he was right. Today, it is Scotland's leading attraction and a chief element of Edinburgh's Old Town's status as a UNESCO World Heritage Site.

It also has dungeons.

Nothing surprising about that, as castles are famous for them, though Edinburgh Castle has renovated theirs into a rather cool interactive display, showing the conditions endured by the thousands of prisoners who languished there over the centuries. The dungeons have, at various times, held French privateers, real pirates from the Caribbean and captives from the Seven Years War, the War of American Independence, the French Revolutionary Wars and the Napoleonic Wars. It wasn't until a mass breakout by French prisoners in 1811 that the authorities decided to build more secure prison buildings elsewhere.

But Edinburgh Castle has a legend that is a mainstay of the city's underground myths. The idea that it contains a secret escape tunnel, leading from the dungeons right under the fortifications.

But where might it come out? There are two theories.

St Margaret's Well

St Margaret's Well was guarded by the Well House Tower, a ruin standing at the foot of Castle Rock, on the edge of Princes Street Gardens. The tower was built as part of the defences when the wall of 1450 was erected, though it now stands in isolated splendour. Many years ago, so popular legend says, a set of steps were discovered underneath piles of debris at the foot of the tower. The steps were hewn out of solid stone and led to a secret passage with a thick, fortified door at the end. It has been suggested that this was intended as a sally port, connecting to an underground passage winding down from the castle. The garrison could then safely send men down to collect water without fear of being attacked. Of course, there is no longer any sign of the stone steps. Mind you, if they did exist, they might have been buried again, to hide the existence of a secret way into the castle. That's not something its defenders would want to advertise.

Theory two is more far-fetched: that the tunnel ran below the Royal Mile itself. However, it gave rise to one of the most enduring legends of Edinburgh's Underground City, and also one of its most notorious ghost stories. So here goes.

In the early nineteenth century, Edinburgh City Council uncovered a mysterious tunnel in the castle dungeons and were, naturally, extremely perturbed. Unfortunately, the entrance wasn't large enough to allow exploration – unless the explorer happened to be particularly small.

Since there were no midgets in the vicinity, the council decided to send a ten-year-old boy into the tiny aperture to see where the tunnel ended up. This may sound like a heartless

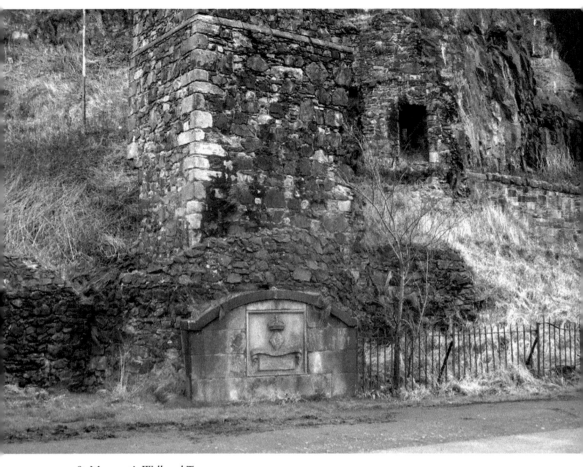

St Margaret's Well and Tower.

thing to do but, in those days, thousands of orphans were employed to climb inside chimneys and sweep them, so a lot of Edinburgh children were used to crawling through small dark spaces. The councillors gave the lad a tiny drum and told him to beat it as he went, in order for them to monitor his progress.

The child wriggled into the cold, black passage and wormed his way out of sight, frantically beating the drum. As the faint rat-tat-tat sound travelled under the High Street, soldiers followed safely along on top, listening to the poor lad's ill-fated journey.

At a spot, just short of the Tron Church, the drumming stopped and Edinburgh Council had a dilemma. Though life was cheap among the city's slum children, they couldn't keep sending ten-year-old after ten-year-old into the tunnel – there was no telling how many they might get through. Instead, the council quietly sealed the entrance back up and hid it.

Does the tunnel still exist? Did it ever exist? Or is it simply a local tale to scare unruly kids? Edinburgh Castle is a military garrison and is hardly likely to give away details or even acknowledge the existence of a passage running right under its fortifications. Yet, it is possible that some sort of tunnel is real. The castle was often under siege and many ancient fortifications used secret passages to sneak messages and important persons through enemy

blockades. The structure of the Old Town makes Edinburgh Castle a prime candidate for just such an escape route.

The legend itself takes many forms. In one popular version, it is a bagpiper who was sent underground, which seems even more dubious. If a burly soldier with a set of pipes could fit into a tunnel, there wouldn't be many people who couldn't. The famed writer Robert Louis Stevenson agreed with this analysis, calling the piper version 'a silly story'. In all the adaptations of the tale, however, the existence of a castle tunnel is the constant factor.

And local residents will tell you that, on some nights, if there is no traffic around, a faint but frantic drumming can be heard below the streets around the Tron Church.

www.edinburghcastle.scot

Interest Rating
Edinburgh Castle 5/5
St Margaret's Well and Tower 3/5

Haunted Rating 4/5
John Graham of Claverhouse (also known as Bonnie Dundee) is said to haunt the ramparts, which is odd, as he died at the Battle of Killiekrankie, which is pretty far away. Phantom drumming was first heard in 1650 and the castle was taken by Oliver Cromwell's forces soon after – leading to the idea that this was a portent for disaster. In later sightings, the drummer is sometimes invisible, often headless and was last reported in the 1960s. The ramparts boast ghostly bagpiping and the invisible marching of massed men. The dungeons are said to be plagued by the ghosts of prisoners held during the Napoleonic Wars.

The castle is also haunted by Janet Douglas, Lady Glamis. She was accused of witchcraft on a trumped-up charge and burned at the stake in 1537, in front of her husband and son. A busy ghost, she also finds time to haunt Glamis Castle in Angus.

6

CASTLEHILL RESERVOIR/TARTAN WEAVING CENTRE

At the top of the Lawnmarket is a major underground attraction open for everyone to see. And it's certainly not what you might expect.

For centuries Edinburgh lacked a safe, clean and reliable water supply, with the inhabitants reliant on rainwater for drinking, washing and cultivating crops. This left Edinburgh Castle at a significant disadvantage. It could hold out against attack but not a siege, for it could get only limited supplies of water. All it had was a relatively small well, a few metres deep, serving as a cistern for storage.

Tartan Weaving Centre (formerly Castlehill Reservoir).

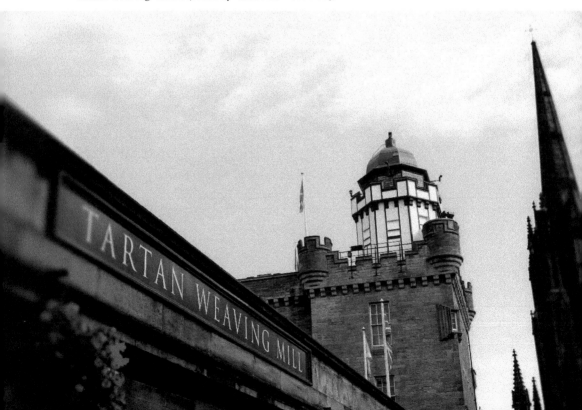

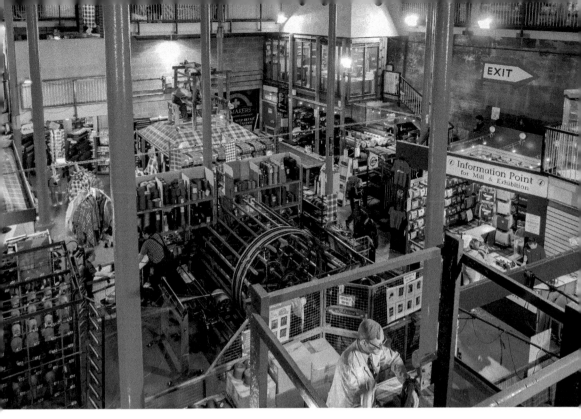

Tartan Weaving Centre interior.

The Nor' Loch was no use as a source, as raw sewage had been pouring into it for years. Though the citizens didn't understand the consequences of drinking contaminated water, the amount of human and animal waste washing into the loch from the city made it pretty obvious that this stinking swamp was truly nasty.

In 1624, the city was granted an Act of Parliament that allowed them to bring fresh water into Edinburgh for the first time. Springs in the Pentland Hills, to the south of Edinburgh, were connected to the city via a network of hollowed-out tree trunks, ending at the top of the Royal Mile. There, a subterranean reservoir was built, which held almost 2 million gallons. It was decommissioned in 1992.

Castlehill Reservoir exists today as the city's only surviving tartan weaving mill. The attraction is huge and fully 5 storeys deep. Now run by Geoffrey Tailor Kiltmaker, the mill exhibition shows the process involved in tartan production, from shearing sheep to making a kilt. There are working looms and it has the atmosphere of a busy factory. The building also plays host to a number of businesses and shops. But the sheer size of this underground enterprise is its most breathtaking aspect.

FUN FACT
Across the street is Castle Wynd (south), which gives an indication of how high up you are. 187 very steep steps lead down to the Grassmarket, with Johnstone Terrace intersecting them. Climbing up has deterred many an unfit tourist from actually reaching the spot.

Interest Rating 4/5

7

THE LAWNMARKET (TOP OF THE ROYAL MILE)

Let's venture down the Mile from the castle. Being at the top, Lawnmarket has by far the most precipitous slopes. Try walking down Ramsay Lane, one of the steepest streets in Britain, on an icy day and you'll see what I mean. Every building here has cellars, some put to innovative use, like the Whisky Heritage Centre and the Witchery Restaurant, where I recommend you have a meal. It's not cheap, but the subterranean dining rooms are an absolute feast for the eyes. Named for many women burned as witches on Castlehill, ironically, it is supposed to be haunted by one of them.

Ramsay Lane.

Lawnmarket (originally the Land Market) was a fifteenth-century marketplace for buying and selling yarn, cloth and linen. A good idea of the congestion on the Mile can be gleaned from an old phrase 'As thrang (crowded) as the Lawnmarket'.

Much of the original Lawnmarket is gone or paved over, including Rockville Close, Kennedy's Close, Stripping Close, Blair's Close, Tod's Close, Nairn's Close and Blyth's Close. However, there are still countless cellars there and most are unknown to the public. I was allowed a peek into this hidden world when I visited a sandwich shop on Bank Street. The manager lifted up a trapdoor in the back and led me down a steep flight of wooden stairs. There was a stone vault at the bottom with a door that, when opened, revealed nothing but packed earth. Where it once led is anyone's guess. The manager had no idea.

Interest Rating 4/5

Haunted Rating 2/5
In the eighteenth century, one of the flats was suddenly abandoned in the middle of a dinner party. The guests locked the door behind them and it was never opened again. By the nineteenth century, the story had passed into lore, with the historian Robert Chambers writing: 'No one knows to whom the house belongs; no one ever inquires after it, no one living ever saw the inside of it, it is a condemned house.' We will never know the truth, for it really was condemned and no longer exists.

The area is also haunted by a hunchback in eighteenth-century dress, dragging a trunk.

Royal Scottish Academy on the Mound.

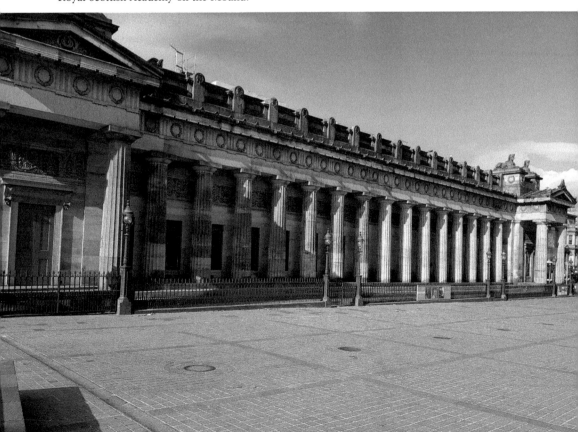

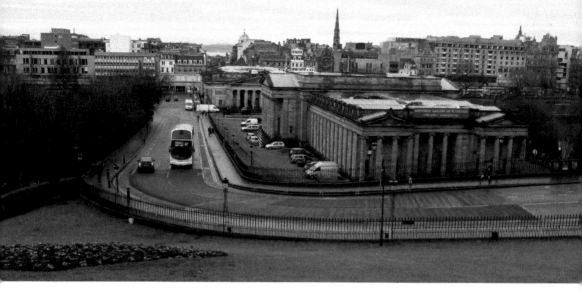

The Mound.

The Mound

Bank Street leads onto the Mound, responsible for covering many subterranean passages. As the New Town (see New Town) gained popularity, more connections to the Old Town were needed. The result was the Mound, formed when developers of the New Town began to dump earth and rubble left over from construction to shore it up (1.5-million tons between 1781 and 1830). Still the main thoroughfare between the Old and New Towns, the Mound is now entirely paved over and what was below is gone forever.

> **FUN FACT**
> The Mound was the brainchild of a clothier called George Boyd. When 'Geordie Boyd's Mud Brig' was widened for carriages, Boyd's house was demolished because it was in the way.

Interest Rating 3/5

Upper Bow and Victoria Street (Just off Lawnmarket)

Victoria Street joins the Royal Mile to the Cowgate and Grassmarket and was built between 1829 and 1834 as part of the city's 1827 Improvement Act. Designed by architect Thomas Hamilton, the street replaced one of the city's main thoroughfares, the West Bow. This was a treacherous, winding scree, providing precipitous access from the Castlehill to the Grassmarket area. Hamilton favoured the neoclassical style but was told to mimic the Old Flemish style instead, and the result is rather beautiful. The buildings are multicoloured and arches lining the new terrace have been transformed into independent shops. During construction, of course, many of the medieval buildings were demolished along with what was underneath.

Interest Rating 4/5

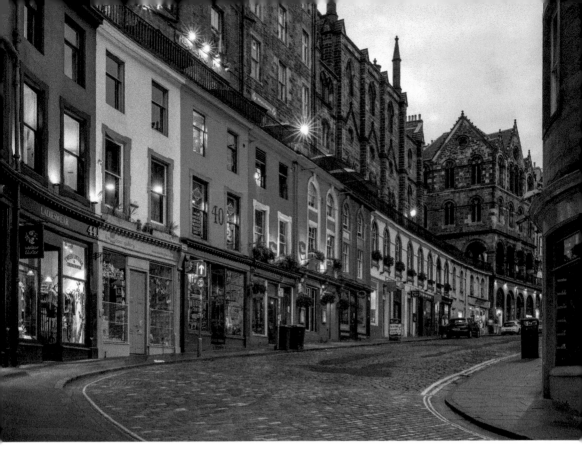

Victoria Street.

Haunted Rating 4/5

Haunted by Major Weir – 'The Wizard of the West Bow' – who lived there. A fiery Presbyterian minister, he suddenly confessed to being in league with the devil and was burnt at the stake in 1690. The street is also haunted by a phantom coach ridden by the devil and the ghost of a sailor named Angus Roy. Crippled on a voyage in 1820, Roy is still seen occasionally, dragging his injured leg behind him. Shame he picked such a steep street to hang out.

Museum on the Mound

The Museum on the Mound, focussing on money and economics, is located in the Bank of Scotland Head Office. Sited at the top of the Mound, it is a large baroque revival building, topped with a splendid dome. The original Palladian-style building was designed by Richard Crichton and Robert Reid and erected between 1801 and 1806. Because of its location, on a steep slope, it has a large subterranean area, part of which now contains the museum. It houses artefacts tracing the glories of the Bank of Scotland since its foundation in 1695, and a history of banking and building societies in Britain. There are also exhibits related to the history of numismatics (whatever that is), ancient tokens, Scottish coinage and paper money.

https://museumonthemound.com

Interest Rating 3/5

Milne's Court

The passing fortunes of the Underground City can be gauged by taking any of its closes or courts as an example. Let's take Milne's Court (formerly Milne's Square), just down the High Street from the Lawnmarket. It was designed by Robert Mylne, one of a family of masons, sculptors and architects, and an early city improver. Made master mason to

Milne's Court.

Charles II in 1668, he helped rebuild Holyrood Palace, strengthened Edinburgh Castle's walls and embarked on a programme to replace the dark narrow closes with tenements built around more expansive courtyards. Which, of course, meant, covering over underground vaults.

The entrance is nothing to write home about, just a stone archway with the date 1690 carved into the brick. Walk through the pend (alleyway), however, and you have a true sense of stepping back hundreds of years, emerging into a courtyard with seventeenth-century tenements towering above. In its day, Milne's Court was distinctly upmarket, housing the rich and famous. By 1871, however, the city census painted a far less flattering picture.

> A densely populated square … irregularly numbered, very dirty, and anything but a free current of air … In one house of three rooms, on Sunday night there slept fourteen souls of different sexes and no family connections.

Things got so bad that, in 1960, the court was deemed unsafe and marked for demolition – only saved by a massive renovation project. Unfortunately, a mistake reinforcing the foundations meant filling in five underground levels. So there's another bit nobody will ever see.

Attraction Rating 3/5

High Street

The High Street begins at Parliament Square and continues down to the junction of Jeffrey and St Mary's Streets, where the Netherbow Port separated the Old Town from the Burgh of Canongate. Again, many areas are now razed, including Paterson's Court, Galloway's Close, Donaldson Close, Old Bank Close, New Bank Close, Libberton's Wynd, Milne Square, Cap and Feather Close, Marlin's Wynd, Dickson's Close, Skinner's Close, Murdoch's Close, James Bane Close and Hodges Close. And, of course, all the underground dwellings they topped went with them.

There's still plenty left to see, though. For example, sixteenth-century Advocates Close was the residence of Lord Advocate Sir James Stewart (1692–1713) and the painter Sir John Scougall (1645–1730) – though the original houses were demolished in 1882. To make up for that, it has one of the great views of Edinburgh, looking down to Princes Street from a height that makes the Walter Scott Monument seem like a toy.

Interest Rating 5/5

8

MARY KING'S CLOSE (HIGH STREET)

Of all the streets and closes in the city, buried or otherwise, Mary King's Close stands out. It is now underground, hidden below Edinburgh Council's City Chambers, opposite St Giles' Cathedral.

The City Chambers was formerly the Royal Exchange and, before that, the residence of Sir Simon Preston, City Provost from 1566 to 1567. The deposed Mary Queen of Scots spent her last night in Edinburgh at his house before being imprisoned in Loch Leven Castle. The original closes in the area were demolished or covered over and the present buildings were designed by John Adam (1721–92), eldest brother of the noted Adams family of architects.

Built as the new home for Edinburgh Town Council, the large central square was intended as a custom-built area for merchants to trade – only the merchants resolutely refused to move from their normal stances across the street in Parliament Square. The courtyard now has a statue of Alexander the Great taming his horse Bucephalus, erected by the famed sculptor Sir John Steell (1804–91). In 1904 another wing was added, completely covering Mary King's Close.

Who exactly 'Mary King' used to be is uncertain and the close itself might have slipped unremarkably into history had it not been for the plague of 1645.

The cramped and filthy conditions inside the Flodden Wall provided a perfect breeding ground for disease and, when plague inevitably arrived, Edinburgh was devastated. Naturally, an epidemic of this magnitude caused a bit of panic among city officials, and their dubious solution was to wall up any area where the dreaded sickness broke out. This fate befell Mary King's Close, closed up while some 600 inhabitants lay dying inside. When the City Council felt it was safe to remove the bodies – two months later – rigor-mortis had taken hold. Wearing herb-filled masks (a useless safeguard, for the plague was transmitted by rat mites), council workers dismembered the corpses with axes and hauled the remains away in carts. The victims were buried outside the city walls in an area now known as the Meadows and Bruntsfield Links – these days a particularly green and fertile park. The council's deeds earned the ill-fated street the nickname 'Bloody Mary's Close'.

Though the plague passed, Mary King's Close remained shut and, as years went by, it became a place of mystery and dread. Open one of these long-closed doors, it was whispered, and the deadly fingers of disease would, once more, grip the city.

It's a great story but not true in any way, shape or form.

Mary King's Close was certainly less than sanitary. Rats ran wild in the close, carrying fleas with them. The fleas became infected with the bacterium *Yersinia Pestis*, better known as the bubonic plague, which spelled disaster for the residents.

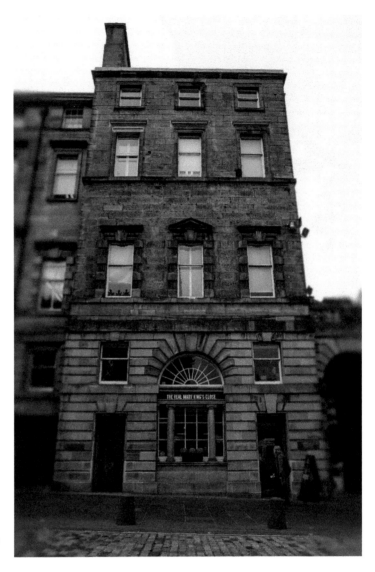

Mary King's Close
exterior.

When the 'Black Death' first appeared, it seemed to only infect England – so the Scots delighted in calling it 'the foul death of the English'. As COVID-19 has taught us, however, nobody is immune. The plague soon made its way to Scotland, the country losing a quarter of its population to the scourge. In the tight quarters of Mary King's Close, like other packed Edinburgh streets, the effect was shattering.

However, they weren't left to die. In reality, plague victims were well cared for and the town council managed the outbreak efficiently and compassionately. Families healthy enough to be moved were taken to Burgh Muir or Bruntsfield Links. Those who were infected put white flags in their windows, so food and coal could be delivered to them. The plague doctor George Rae visited wearing a leather outfit and a bird-shaped mask to help protect him from the disease. His treatment was to cut off the top of the victim's sore and jam a red-hot poker into the wound to cauterize it. Nasty as all hell but it sometimes worked.

Steps over
Mary King's
Close.

Nor was Mary King's Close abandoned afterwards. People continued to live there until the nineteenth century and the last resident, saw-maker Andrew Chesney, left in 1904. By this time, however, his dwelling was underground.

The lower half of Mary King's Close was demolished in 1853 to allow for the construction of Cockburn Street. However, the upper half was simply covered over. The Royal Exchange was built on top of it and the street forgotten. It wasn't rediscovered until workmen digging on the road above accidentally punched down into the winding lane.

Today, Mary King's Close is a spectacular visitor attraction, with guided tours by historical re-enactors. Council business continues in the corridors of power above – and some passages of the close below, bizarrely enough, were used to house filing cabinets (presumably documents that were not needed very often).

FUN FACT
George Rae completely misunderstood how the Black Death worked, thinking it was airborne. However, his leather outfit and mask stopped fleas from biting him and he survived.

https://www.realmarykingsclose.com

Attraction Rating 5/5

Haunted Rating 4/5

Mary King's Close gains much of its haunted reputation from the 1685 bestseller by Professor George Sinclair: *Satan's Invisible World Discovered or A Choice Collection of Modern Revelations, Proving Evidently, Against the Atheists of this Present Age, that there are Devils, Spirits, Witches and Apparitions*. This tome painted the close as a supernatural hotbed, but the title alone should indicate its contents be taken with a pinch of salt.

In the 1990s, renowned Japanese psychic Aiko Gibo visited the close. Stepping inside a seventeenth-century room, she could barely enter for the pain and unhappiness she felt, stating:

> I cannot enter this room ... it is too strong ... there is a child beside me, her little hand is clutching my trouser leg. I ... I just cannot go into this room ... she was separated from her parents. She wants to go home and see her family ... her desire haunts this place very strongly.

Inside, she communicated with the young girl's spirit near the fireplace. 'Annie' had lost her favourite doll and was heartbroken. Gibo purchased a doll and returned, apparently bringing comfort to the child. Visitors began to leave her dolls from all over the world and now there's a whole room full of them. This is either touching or immensely creepy, depending on how much you like dolls and children. The original, unfortunately, has now disappeared. If you're interested in bringing another, it was part of the 'Daisy Doll Airline Collection' by the iconic fashion designer, Mary Quant.

Below and pages 36–39: Mary King's Close.

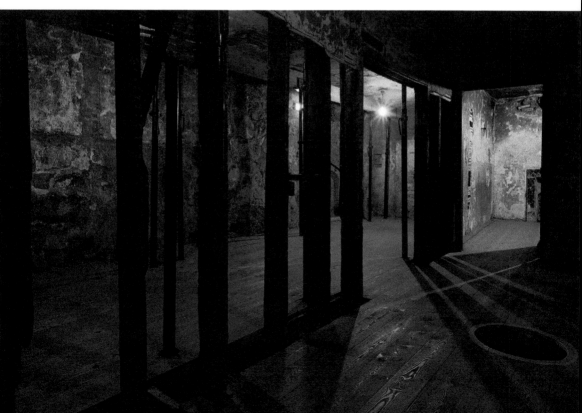

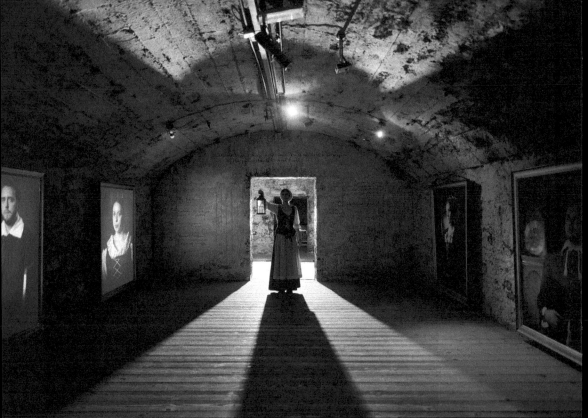

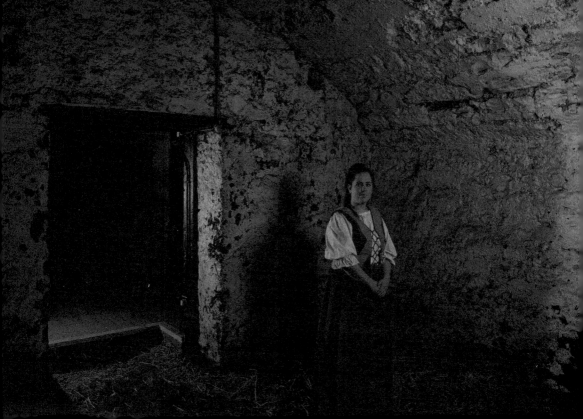

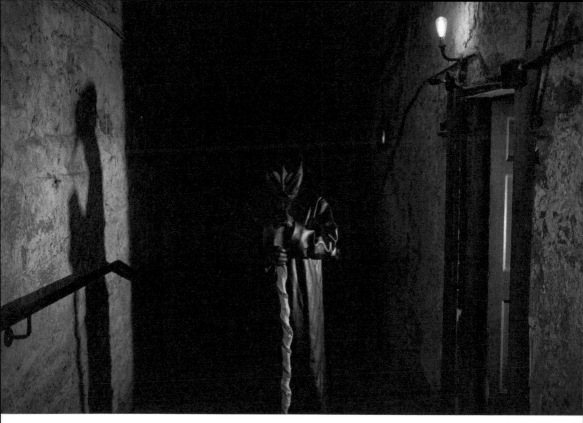

Above: Plague doctor in MKC.

Below: Laigh House, MKC.

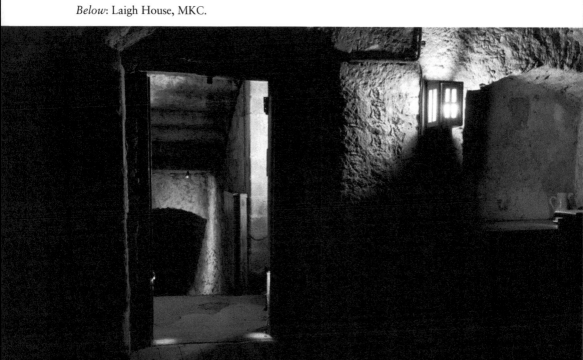

Annie's Room, MKC.

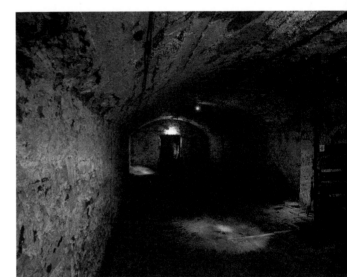

Right: Cow Shed, MKC.

Below: Bruntsfield Links.

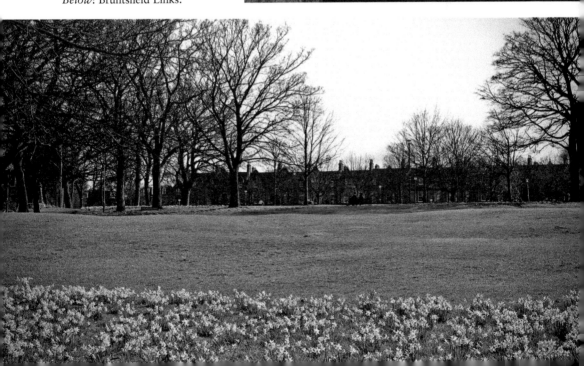

9

PARLIAMENT SQUARE (HIGH STREET)

Parliament Square was the site of the tallest buildings on the Royal Mile, one reaching fourteen storeys high. Those are gone now, but you can still get a sense of the strangeness of the Royal Mile landscape by looking at Parliament House behind St Giles' Cathedral. Begun in 1632, Parliament House is not particularly high. Go down Barries Close next door and into the Cowgate and you get a completely different perspective. Looking up at the rear, from the Cowgate, the building towers over your head. Imagining how high the old edifices once looked from down there is almost vertigo-inducing.

Like many structures on the upper Royal Mile, construction on such a steep slope required a vast amount of under building. Ground-level structures on the High Street could be storeys high at the back. Burton's *Life of Hume* vividly records this Alice-in-Wonderland effect.

> Entering one of the doors opposite the main entrance, the stranger is led ... down flight after flight of the steps of a stone staircase, and when he imagines he is descending far into the bowels of the earth, he emerges on the edge of a cheerful crowded thoroughfare, connecting together the old and new town ...When he looks up to the building containing the upright street through which he has descended, he sees that vast pile of tall houses standing at the head of the Mound which creates astonishment in every visitor of Edinburgh.

Today, the main building of Parliament House has three storeys: the Great Hall, the subterranean Laich House and a vaulted stone undercroft even farther underground. This building was the seat of the Scottish Parliament until it was dissolved by the Union of Scotland and England in 1707 but has its own share of ghastly history, as recorded in *Grant's Old and New Edinburgh* (published in the 1880s).

> The rooms below the Parliament Hall, which are still dark - one being always lighted with gas, the other dimly and surrounded by a gallery - were the places where the Privy Council met, and torture went on, too often, almost daily at one time. Though long dedicated now to the calm seclusion of literary study, they are the same that witnessed the noble, the enthusiastic, and despairing, alike prostrate at the feet of tyrants, or subjected to their merciless sword. There Guthrie and Argyle received the barbarous sentence of their personal enemies without form of trial, and hundreds a less note courageously endured the fury of their persecutors.

Parliament Square bears no resemblance to how it once looked. The Old Tolbooth, Edinburgh's Prison, was demolished. St Giles' Graveyard (between Parliament House and St Giles') is now a car park, the steep stairs from the Cowage to the Square were covered over and the towering tenements are gone. The entire east side of the square was destroyed by the great fire of 1824, putting paid to many more of its underground features. *Grants Old and New Edinburgh* lamented the passing of a particular hidey-hole.

> In one of the houses consumed on this occasion was a cellar or crypt in which Dr. Archibald Pitcairn, the celebrated wit, poet, and physician, who was born at Edinburgh in 1652, was wont to pass many a jovial evening about 120 years before the conflagration. The entrance to this gloomy place was opposite the eastern window of St. Giles, and it descended from under a piazza. A more extraordinary scene for the indulgence of mirth and of festivity than this subterranean crypt or den – facetiously named the Greping Office – certainly could not well be conceived, nor could wit, poetry, and physic well have chosen a darker scene.

However, Parliament House and St Giles' Cathedral are still well worth checking out for their rich history and architecture. Mercat Tours and City of the Dead Tours leave from Parliament Square and venture into the South Bridge Vaults, part of Edinburgh's legendary 'Underground City' (see South Bridge).

Attraction Rating 4/5

Parliament Square.

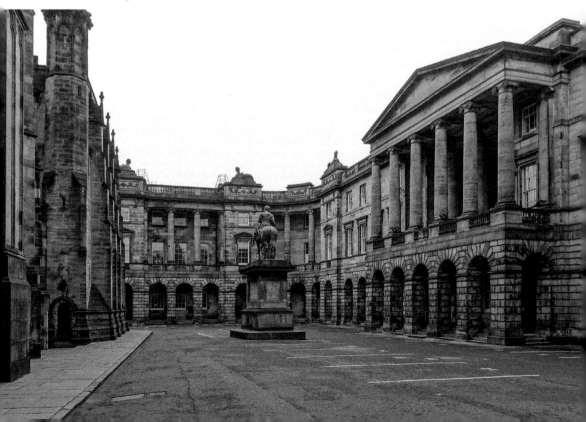

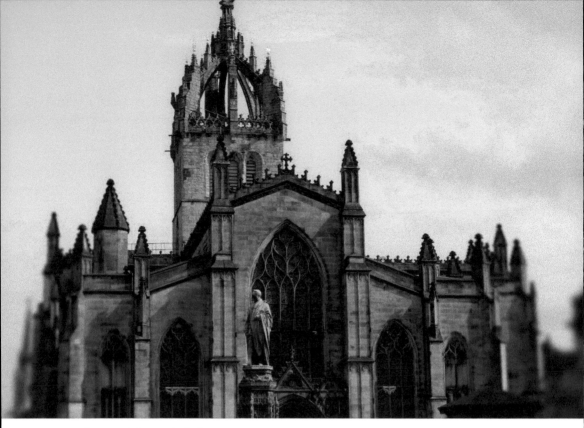

Above: St Giles' Cathedral.

Below: Barrie's Close, off Parliament Square.

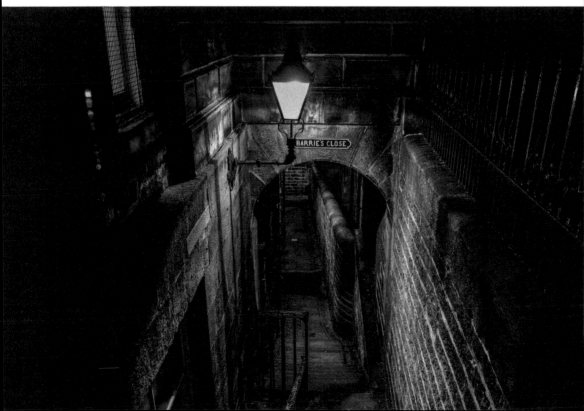

10

TRON KIRK AND MARLIN'S WYND (HIGH STREET)

This seventeenth-century landmark is named after the wooden Tron Beam weighing scales, situated outside. The Kirk was erected between 1636 and 1647, a design that mixed Palladian and Gothic elements, inspired by contemporary Dutch architecture, with a magnificent internal hammer-beam roof. The wooden spire, added by Thomas Sandilands in 1671, burned down in the great fire of 1824 and was replaced by stone in 1828. There are still apparent scorch marks on the stone walls inside the building. Or perhaps it's just dirt.

The Kirk was founded by King Charles I (1600–49) to house the congregation displaced from nearby St Giles', when he made that church a cathedral. In 1952 the building closed as a place of worship and was acquired by Edinburgh Council.

But what is of interest to us lies under the floor. Internal excavations in 1974 revealed foundations of sixteenth-century buildings in Marlin's Wynd, Edinburgh's oldest cobbled street.

Marlin's Wynd (also known as Marlyn's Wynd) was typical of many Old Town thoroughfares. It was crowded, bustling and diverse, housing corn and poultry markets and littered with bookstores and stalls. Built in 1532, it is generally acknowledged to be the first paved walkway in the city. And, as with all the streets of Old Edinburgh, Marlin's Wynd has its own peculiar legend. It was named after John Merlouin, a French stonemason who paved parts of the Royal Mile and designed the ancient gateway of Holyrood House. He and his family had a dwelling at the head of the alley and Merlouin is believed to be buried here, his tomb marked for posterity by six flat stones in the shape of a grave.

In 1786, many of the houses were demolished to make way for the construction of the South Bridge (see South Bridge). Below ground, however, the vaults of Marlin's Wynd, although structurally part of the bridge, continued to be put to use by the occupants of the new tenements. Here are a couple of examples.

To the west, at Blair Street, lived Andrew Wardrop. One of the city's foremost surgeons, he must have found the almost sound-proofed cellars ideal for drowning out screams from his operating theatre. To the east, Marlin's Wynd's vaults were used by the Stewart family. They were well-respected bankers, best known for the foundation of Daniel Stewart's College, though they also made a fortune from the slave trade.

In the 2000s, the Tron became an information centre, with raised walkways showing the splendour of Marlin's Wynd underneath. Unfortunately, it was covered again, in order

to house a rather shabby market. It is presently leased to Edinburgh World Heritage and contains a rather underwhelming exhibition – explaining what makes Edinburgh's heritage so special – told through the voices and opinions of local people. Most opinions are that Marlin's Wynd should be on display again, but that hasn't happened. Unfortunately, a common occurrence in the city.

At least the other end of Marlin's Wynd is popular again. Nearly 500 years on, the cellars where it existed have been brought back to life. Restored, renovated and splendidly refurbished, the stone walls glow with candlelight and ring with noise again. These splendid, vaulted cellars are used for weddings, parties and private dining. You can also see original terracotta floor tiles, a hearth stone, what remains of a fireplace and an old well (see the South Bridge).

FUN FACT
Criminals had their ears nailed to the Tron Beam as punishment.

Attraction Rating
Tron Kirk 2/5 (4/5 if the floor is ever lifted)
Marlin's Wynd 5/5

Tron Kirk.

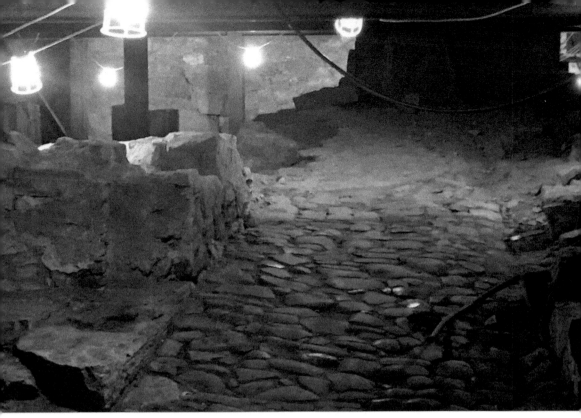

Top, right and above: Upper Marlin's Wynd (under the Tron).

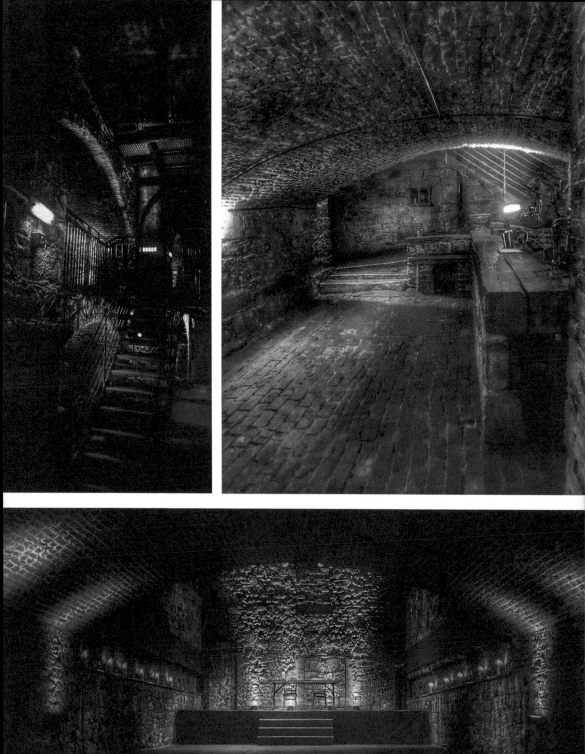

Right, below and opposite: Marlin's Wynd.

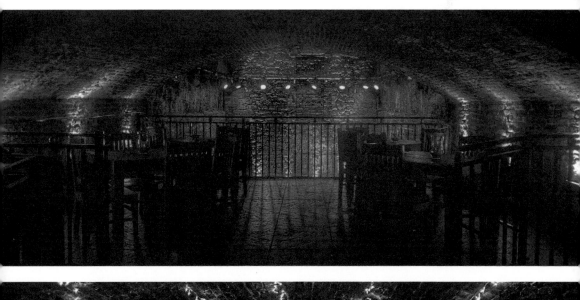

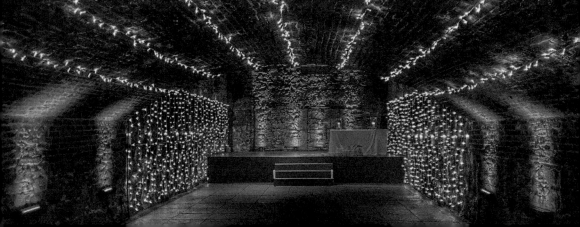

Entrance to Marlin's Wynd.

11

THE UNION CELLAR

On 25 March 1707, the Treaty of Union was ratified, a pact with England that effectively ended Scotland's right to govern itself. So unpopular was this move – considered by most Scots to be the death of their nation – that the document had to be signed in secret. This was a truly momentous step which, despite the citizens' outrage, changed the fortunes of the country. It was soon followed by the 'Scottish Enlightenment' and Scotland was transformed from a poverty-stricken backwater to a world leader. If that wasn't enough, the industrious, enterprising and pushy Scots went on to form the backbone of the British Empire.

But where was the treaty actually signed? Underground seemed like a perfect place to hide and cellars under Parliament Square or below Alexander Borthwick's Tavern in the south-west corner of Milne's Square (see Milne's Court) have both been cited. Sadly, these

Moray House.

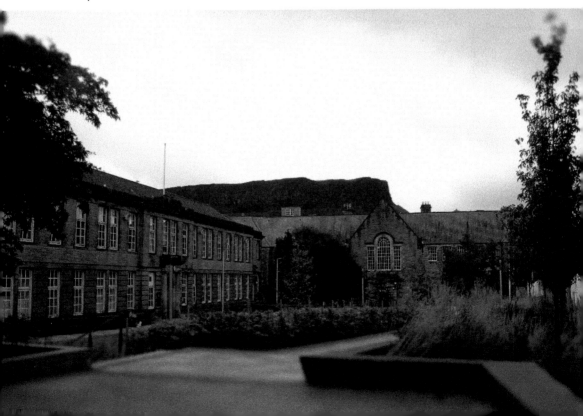

have all been filled in or demolished. However, *Grants Old and New Edinburgh* gives two more likely locations.

> Under terror of the Edinburgh mobs, who nearly tore the Chancellor and others limb from limb in the streets, one half of the signatures were appended to the treaty in a cellar of a house, No 177, High Street, opposite the Tron Church, named 'the Union Cellar;' the rest were appended in an arbour which then adorned the Garden of Moray House in the Canongate; and the moment this was accomplished, Queensberry and the conspirators - for such they really seem to have been - fled to England before daybreak, with the duplicate of the treaty.

Moray House is now a teacher training college and a perfect example of how quickly hidden chambers can be forgotten. In the twentieth century, Edinburgh Council launched an energy conservation study to cut costs in the building and unearthed an electricity meter hidden behind a locked cellar door. It had not been read for fourteen years and landed the college with a potential bill of thousands of pounds.

The Union Cellar still exists and is easily located, though it may come as a bit of a disappointment. It is now the basement of an Italian restaurant.

Interest Rating 1/5 (2/5 if you like pizza)

12

COCKBURN STREET

This is yet another artificial street, built over several demolished closes, including one where the poet Robert Fergusson (1750–74) was born. It is named after the judge and journalist Henry Lord Cockburn (1779–1854). Cockburn was a member of the Speculative Society, founded in 1764 and dedicated to debate and literary composition. Other members included Walter Scott, Lord Chancellor of Britain, Henry Brougham (1778–1868), judge and literary critic Francis Jeffrey (1773–1850) and Robert Louis Stevenson (1850–94). If you go into the Viva Mexico restaurant there, you'll find yourself eating in a large vault under the street. Look out the window, however, and you are above one of the steep closes leading to Market Street. Such is Edinburgh.

Interest Rating 4/5

Cockburn Street.

13

A SHORT HISTORY OF EDINBURGH (CONTINUED)

'But Edinburgh is a mad god's dream.'

Hugh MacDiarmid

The further down the Royal Mile you go, the less raised the land. Though there are cellars galore, the most interesting Mile sites have already been covered. So now we come back to history for the next phase of the Underground City.

Edinburgh remained a rough and ragged place long after the other great capitals had cleaned up their act, and the city remained walled up until the mid-eighteenth century. This was not being over-cautious, for Edinburgh was invaded as late as 1745, captured by Bonny Prince Charlie on his way south to try and regain the British throne. This bold conquest was always doomed and, a year later, Charlie's retreating highland army was annihilated at Culloden. It was to be the last battle fought on the British mainland and peace came at last to Scotland.

By the late eighteenth century, however, Edinburgh's status had changed beyond recognition. To the astonishment of the world, and presumably its own citizens, it went from being a cultural nonentity to 'The Athens of the North' – the marvel of modern Europe and home to the finest minds of the day. It led the planet in architecture, education, law, philosophy, maths, engineering, economics, medicine and science. The poet and author Tobias Smollett (1721–71) called it a 'hotbed of genius' and that's a massive understatement.

The reason for this may have been because overcrowding forced both great minds and normal people to freely mingle and exchange ideas. But the cramped conditions of the Old Town could not be endured for much longer. The Flodden Wall was falling into ruin and the population could finally spread out onto the surrounding land.

Unhealthy and overcrowded Edinburgh sorely needed a visage to match its newfound status and that's when George Drummond (1687–1766) came along.

Politician and visionary planner, Drummond became Edinburgh's most famous Lord Provost, holding the office six times. He was also responsible for initiating the biggest programme of public works the city has ever seen. Drummond raised funds to build the Royal Infirmary, which quickly became one of the world's foremost teaching hospitals and commissioned the Royal Exchange, which later became the City Chambers. He helped enlarge the University of Edinburgh and established five chairs of medicine. But he is best known as the driving force behind the building of Edinburgh's 'New Town'. He persuaded

the Town Council to support an ambitious plan to create a grand extension on the north side of the city and hold a competition for the design. In 1776, it was won by an unknown twenty-six-year-old architect called James Craig. Drummond had the Nor' Loch drained and proposed a huge bridge as the gateway to the New Town, laying its foundation stone in 1763.

Edinburgh's engineers got to work and were well up to the task. Edinburgh University had started lectures in civil engineering in 1800 – almost a quarter of a century before the rest of Europe – and virtually all early civil engineers visited the city at some time.

FUN FACT

Drummond was a noted Unionist who fought against the Jacobites in 1715 and raised militia to repel Bonnie Prince Charlie from Edinburgh. Unfortunately, they ran away when they saw the highlanders coming, armed to the teeth.

The New Town

The New Town turned out to be an astonishing achievement and symbolic of the Scottish Enlightenment and its beliefs – that society and its environment could be improved by logical and pragmatic thinking. It was deliberately functional and uncomplicated, based on Greek, Classical and Roman designs. It was also grand and breathtakingly handsome, with

Typical New Town street.

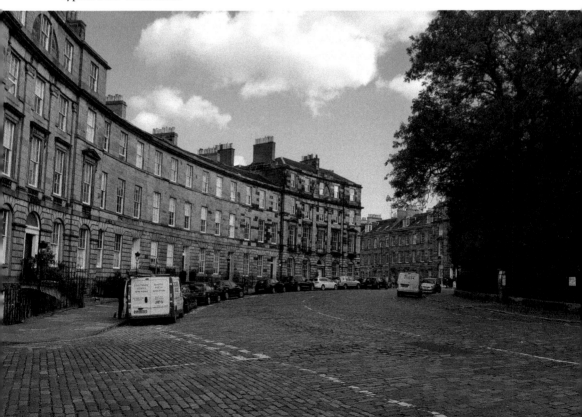

long vistas and plentiful green space, at regular intervals, the unified frontage giving the impression that entire terraces were one giant palace.

Interest Rating 5/5

Modernisation did not stop there. Along with the North Bridge, four more bridges were constructed between 1765 and 1833, creating an architectural vista no contemporary city could match. In 1905 the novelist G. K. Chesterton wrote in the *Daily News*.

> The beauty of Edinburgh as a city is absolutely individual, and consists in one separate atmosphere and one separate class of qualities. It consists chiefly in a quality that may be called 'abruptness', an unexpected alternation of heights and depths. It seems like a city built on precipices: a perilous city. Although the actual valleys and ridges are not (of course) really very high or very deep, they stand up like strong cliffs; they fall like open chasms. There are turns of the steep street that take the breath away like a literal abyss. There are thoroughfares, full, busy, and lined with shops, which yet give the emotions of an alpine stair. It is, in the only adequate word for it, a sudden city.

This 'suddenness' was partly due to the way bridges were integrated with the city. They were not simply built but blended into existing streets, like an architecturally aesthetic haircut. The gaps they spanned were filled in, developed and built up. Buildings were constructed above and on either side until the mighty structures were almost totally concealed.

And, inadvertently, they created another part of the Underground City.

Under each bridge was a mass of chambers and vaults, often connected to the hills they joined. At first, they were open to the air, but as urban development continued, each became almost invisible, hidden behind newly constructed dwellings.

Having vaults under the supporting arches of each bridge was perfectly logical. Why fill in valuable storage space – especially in a city as crowded as Edinburgh – when engineers could now fill the underside of bridges with stone chambers? After all, empty vaults could be put to all sorts of uses. In the end, these hidden chambers were put to some uses the city planners could never have imagined.

We'll take a closer look at the bridges in a minute. First, I propose you take a little walk.

14

THE BRIDGES WALK

There is a journey you can embark on which is pretty mind-blowing. It perfectly illustrates the crazy topography of central Edinburgh and what a phenomenon these bridges were.

Start on Calton Hill, an impressive site in itself, studded with stone monuments. It towers over the New Town to the north and Princes Street to the east, providing one of the great Edinburgh views.

On the south side, however, it doesn't seem too high. If you come down the steps near the Dugald Stewart Monument, you end up on Regent Road, at the beginning of Regent Bridge. You're obviously still in an elevated position, for you can look down on the Canongate and across to where Salisbury Crags and Arthur's Seat rise on the other side. Continue west and Old Calton Graveyard rises *up* on the left (the bridge construction cut right through it, causing parts to be relocated). Now you find yourself on top of Regent Bridge and can see Calton Road far below. Continue to Waterloo Place and you find yourselves at a crossroads.

Princes Street is straight ahead. To the left is Leith Street, leading down towards Leith. This is artificial, too, to offset the plunging camber that was once there. If you want a demonstration of how it works, stand outside the Black Bull pub at the junction of Leith Street and Calton Road and marvel at the different elevations. Even better, go in and have a pint in the vaults under Leith Street.

Ignore all that, for now, and turn right on Waterloo Place. You are now on the North Bridge. Below is Waverley station and the sheer sides of Old Calton Gaol are on the left. Keep going along the North Bridge, across the Royal Mile at the Tron Kirk, and you are on top of the South Bridge.

While Niddry Street and Blair Street vanish into the Cowgate on either side, the South Bridge dips slightly, then rises again (see fun fact). Soon you come to a gap, where you can peer into the Cowgate from far above. Continue along the bridge and turn right into Chambers Street. Walk the length of Chambers Street to the Museum of Scotland (which has underground entrances) and you reach George IV Bridge. Cross the road and, once again, you'll see evidence of just how up and down the area is. At the statue of Greyfriars Bobby, Candlemaker Row winds steeply down to the Grassmarket, with walled Greyfriars Graveyard far above it (partly the result of earth brought in to cope with the sheer number of bodies buried there).

Go right along George IV Bridge and you'll find another gap, with the Cowgate far below again. Then you pass Victoria Street (partially artificial) and end up on the High Street. Cross over and you are on Bank Street (with the sandwich shop I mentioned earlier), then the (totally artificial) Mound, taking you down to Princes Street.

As well as breathtaking views and some pretty interesting shops, this walk is the best illustration I can think of to demonstrate the utterly unique geography of the area – and the ingenuity of the early engineers who tried to conquer it.

Interest Rating 4/5

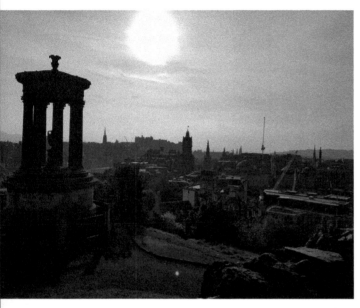

Left: Princes Street from Calton Hill.

Below: New Town from Calton Hill.

Canongate Kirkyard from Regent Road.

15

THE BRIDGES

The North Bridge

Once the Nor' Loch was drained, the first stone of the original bridge was laid on 21 October 1763 by George Drummond. Construction immediately ran into trouble, for the Old Town side of the slope consisted of a great deal of loose earth. This, combined with other design faults, led part of the structure to collapse, killing five people. Rebuilding work continued and the bridge finally opened in 1772. It measured 1,270 feet and was supported by three main arches, two smaller ones and a number of hidden vaults.

You can probably guess the direction the legend of the Underground City was about to take.

The current North Bridge was constructed from 1894 to 1897 and is 525 feet long. It has three spans of arched girders, each 175 feet in length. Even so, it wasn't without flaws.

Below and opposite above: North Bridge.

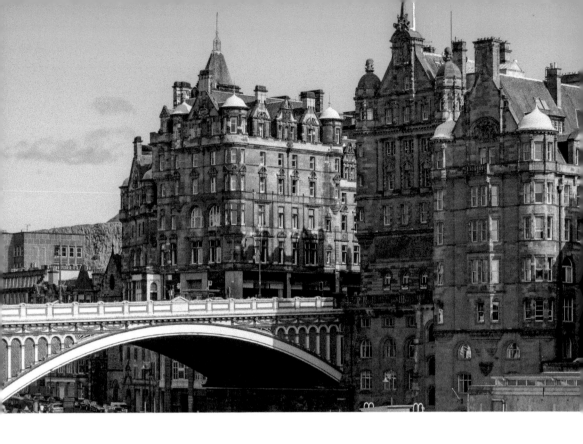

Below: Balmoral Hotel.

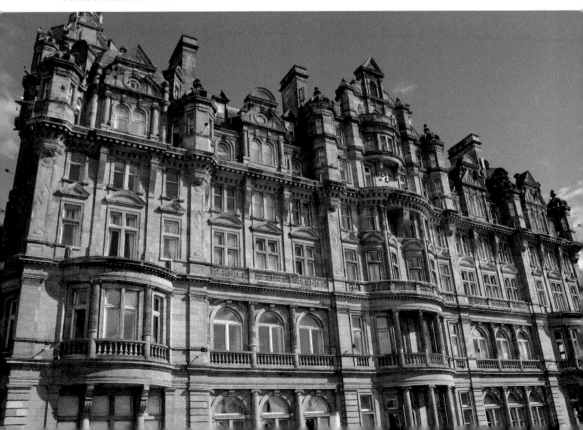

Open sides with railings allowed the mighty Edinburgh winds to blow passengers from the pavement into the mud in the middle of the road.

On the west side is The Scotsman Hotel, former headquarters of The *Scotsman* newspaper, alongside a block of commercial premises and flats. At the northern end of the bridge, where it meets Princes Street in the New Town, is the Balmoral Hotel (formerly the North British Hotel).

And, of course, there are vaults.

FUN FACT
Ever practical, the city magistrates of the time proclaimed that all beggars found in the streets should be imprisoned under the bridge and fed on bread and water.

Attraction Rating 3/5

Haunted Rating 2/5
The *Scotsman* Newspaper Headquarters had a phantom printer and a blonde ghost in a blue dress, but they aren't seen anymore. Either you can't believe everything you read in the press or the present hotel is too expensive for them.

The Balmoral Hotel

This Franco-German-style building, above Waverly station, was completed in 1902 and I can testify as to hidden delights underneath. In the late 1980s, I was working in the basement as a dishwasher (when it was still the North British Hotel) and found an old service elevator. Though the stairs descended several levels, the elevator went one more. It opened into a stone tunnel and since I had no flashlight, I only dared venture down a short way. After an understandable attack of the heebie-jeebies, I never went back and was fired soon after. A few months later, it was renovated and changed to the Balmoral. If you ever find yourself fortunate enough to stay there, sneak down, take a look and tell me where it actually goes.

Attraction Rating 3/5 (5/5 if you actually stay there.)

Regent Bridge

In the early nineteenth century, it was difficult to enter Edinburgh by the Great London Road. From the south, the route threaded through narrow and run-down streets. In 1814, they were swept away and Regent Bridge was built to connect Calton Hill with Princes Street. The bridge was designed by Archibald Elliot (1761–1823), who is buried in New Calton Cemetery, close by. Construction, under the direction of Robert Stevenson (Robert Louis Stevenson's father), began in 1816 and the bridge was finished in 1819. The arch is 50 feet wide and 45 feet high and the street along the top is Waterloo Place.

Attraction Rating 3/5

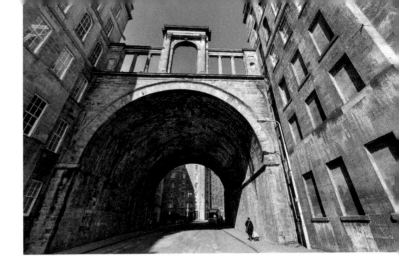

Regent Bridge.

George IV Bridge

This bridge, spanning the Cowgate valley, followed a familiar pattern, requiring the destruction of many existing buildings and streets (including Gosford Close, Mauchine's Close and Liberton Wynd). Named after King George IV, and completed in 1836, most of the arches are hidden by later buildings. At the junction with the Mile, three brass plates mark the site of Edinburgh's last public execution, where murderer George Bryce was hanged in 1864. It contains Edinburgh's Central Library, built over the house of the 1st Baronet of Craighall, Sir Thomas Hope (1573–1646), who helped draft the Solemn League and Covenant. It is also the site of the National Library, which contains every book ever printed in Scotland – as well as the Elephant House Café, where J. K. Rowling wrote the first *Harry Potter* book.

300 metres in length, the bridge connected the South Side district of Edinburgh to the Old Town. At the southern end of the street is the junction with Candlemaker Row, where the famous statue of 'Greyfriars Bobby' stands. Opposite is the junction with Chambers Street, site of the National Museum of Scotland.

George IV Bridge has three open groined arches that can be seen from the Cowgate, but another eleven arches are hidden – closed up to make vaults for properties on either side. Again, these vaults were put to many an odd use. On top of the bridge, a sheriff court occupied the site where the National Library now stands, and officers used the buried chambers below to hold prisoners awaiting trial.

This created yet another strange architectural dichotomy. Go into the Central Library on top and you can descend for flight after flight of stairs until you are below the bridge but above the Cowgate. Two of the pictures I have included are 2011 plans by Allan Murray Architects Ltd, outlining an idea for turning the whole place into a literary hub. But this is Edinburgh, so it never happened and the council have given permission for another hotel instead. The pictures do, however, give a splendid indication of the bridge's structure.

FUN FACT
Greyfriars Bobby, on the bridge, is the most photographed statue in Scotland. But do *not* rub his nose to make it shiny. He doesn't like it.

Attraction Rating 3/5

Haunted Rating 2/5

The bridge vaults under the National Library, which were used to imprison debtors, are supposedly haunted by an unidentified highland chief in manacles.

Left: Cowgate from George IV Bridge.

Below: George IV Bridge.

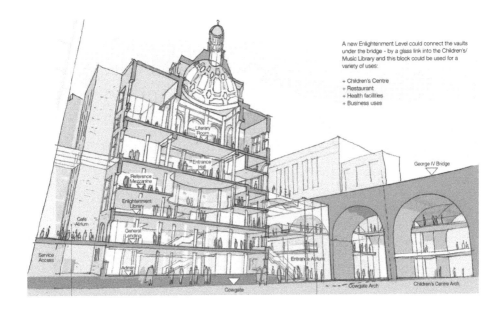

A new Enlightenment Level could connect the vaults under the bridge - by a glass link into the Children's/Music Library and this block could be used for a variety of uses:

+ Children's Centre
+ Restaurant
+ Health facilities
+ Business uses

Above and right: George IV development plans by Allan Murray Architects.

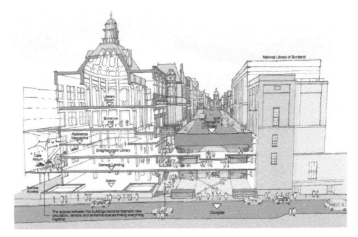

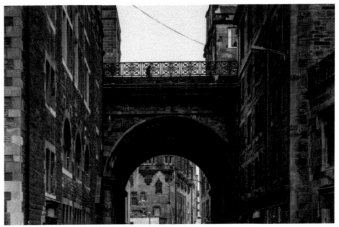

George IV Bridge arch over the Cowgate.

16

THE SOUTH BRIDGE

Of all the bridges, one stands out in Edinburgh's mythology, its vaults and chambers providing a wealth of stories that add hugely to the legend of the Underground City.

Old Niddry, Marlin and Peebles Wynds were demolished to create space for the building of the South Bridge, while two higher areas (Blair Street and Hunters Square) were created beside it. The foundation stone was laid in 1785 and the bridge was opened to foot passage the next year – it was built with astonishing speed. This giant structure is over 1,000 feet long and is, to all intents and purposes, invisible. Spanning the Cowgate valley, between the Royal Mile and the growing University of Edinburgh on the Southside, only one 30-foot-high arch can be seen. Another eighteen giant arches are completely hidden by tenements.

The South Bridge was Edinburgh's first purpose-built shopping street, intended as a hub of commerce, so as much space as possible underneath was utilised. The hidden arches of the bridge were given extra floors and there are approximately 120 rooms or 'vaults' beneath the surface, ranging in size from 2 square metres to 40 square metres. The South Bridge officially opened for business on 1 March 1788.

At first, the vaults were used as storage space and workshops for the businesses above. Traders also set up as cobblers, drapers, wine merchants and jewellers in the caverns. Twisted aristocrats are supposed to have used some chambers for drinking and debauchery – and even occult practices – part of a depraved fraternity known as the Hellfire Club.

This state of affairs didn't last long. Construction of the bridge had been rushed and the surface was never sealed properly against water. As a result, the vaults were permanently damp and prone to flooding. From 1795 onwards, they were steadily abandoned by the businesses who were supposed to use them. But, in overcrowded Edinburgh, empty space was at a premium, and soon the vaults were being used for purposes never envisaged by the builders: living quarters.

The Cowgate had been a fashionable area and, in the early eighteenth century, housed two dukes, sixteen earls, seven lords, seventeen lords of session, thirteen baronets, three commanders-in-chief and a boarding school for young ladies. But the well-to-do deserted their old haunts for the New Town and the underprivileged rushed into the vacuum, transforming the Cowgate from an upmarket locale to a slum. Before long, the Grassmarket – in the shadow of the castle itself – suffered the same fate. The tenements fell into disrepair and the warren of airless cellars that peppered the steep slopes of the High Street were filled to capacity.

One might ask why this was necessary? After all, by the end of the nineteenth century, the Flodden Wall was a ruin and Edinburgh's New Town was spreading out leisurely in the north. Surely there was enough space for everyone in the city to live with some degree of comfort?

To some extent, there was, if you had money to pay for it. The picturesque New Town – still breathtaking today – attracted the more affluent citizens and they left the Old Town in droves. This should have left more room for everyone left behind, but the opposite was true. A combination of economic and political factors meant new immigrants were flooding into Edinburgh. The Industrial and Agricultural Revolutions had caused mass unemployment in the countryside, while city factories thrived on cheap labour. Famine compelled thousands of destitute Irish families to leave their native land and try to scrape a living in Scottish cities. In the north, the 'Highland Clearances' forced entire clans from their ancestral lands and those who did not emigrate had only one place to go: the cities.

Between 1800 and 1830, the population of Edinburgh doubled.

There was one part of Edinburgh with enough cheap housing to accommodate such a flood of poverty-stricken immigrants: the slums and the bridge vaults of the Old Town. The crushed and crowded closes, sloping away from the High Street, became more crowded than they had ever been. If anything, the conditions on the Royal Mile were worse than in the Middle Ages. G. H. Martin's account of Edinburgh in the 1840s painted a bleak picture of the fate awaiting this tidal wave of unfortunate humanity.

Wages were low because labour was readily attracted by the apparent wealth in the city, but accommodation was comparatively cheap because the old properties lent themselves both in their structure and by social customs, to the repeated subdivision of tenements. It therefore became, for many of its immigrants, a social trap from which there was no escape but death.

Under the South Bridge, along the Cowgate and Grassmarket, and in the tiny closes of the Royal Mile, the poor lived in conditions of astonishing deprivation. Many buildings were derelict and dangerous – their ownership forgotten – but people were crammed into them like sardines. Once again, there wasn't room in the Old Town to swing a rat.

Dorothy Wordsworth (1771–1855), viewing the tenements on a visit to Edinburgh, wrote that they 'hardly resembled the work of men, it is more like the piling up of rocks', while Robert Louis Stephenson described cellars 'high above the gazers head'.

The Underground City was thriving in a most horrible way, its cellars and vaults teeming with beggars, urchins and vagabonds.

As late as 1850, there are accounts of families living underground in deplorable conditions. In 1845 George Bell MD, an early social reformer, published a horrific account of life in Blackfriars Wynd, next to the South Bridge.

In a vault or cave under a large tenement, reside an old man, his invalid wife, and his two daughters, one of whom has a natural child and the other of whom is paralytic. The man has an air of respectability about him, but the family has no visible means of living. There were three beds in the vault; and on investigating the matter, (we) found that the said vault is a lodging house, and is often tenanted to repletion. This man is the type of class who live by subletting their miserable and dark abodes to as many as can be crammed into them. In another vault in the wynd we found a very fat Irishwoman, a widow, a pauper, and the mother of six children. By her own confession she occasionally takes in a lodger - in reality, however, she accommodates two or three all the year round.

Robert Louis Stevenson also painted an inimitable portrait of life in the nineteenth-century Old Town:

> You go under dark arches and down dark stairs and alleys. The way is so narrow that you can lay a hand on either wall: so steep that, in greasy weather, the pavement is almost as treacherous as ice... and the pavements are encumbered with loiterers.
>
> These loiterers are a true character on the scene. Some shrewd Scotch workmen may have paused on their way to a job, debating Church affairs and politics with their tools upon their arm. But the most part are a different order - skulking jail birds; unkempt, bare foot children; big mouthed, robust women, in a sort of uniform of striped flannel petticoat and short tartan shawl: among these, a few supervising constables and a dismal sprinkling of mutineers and broken men from higher ranks in society, with some mark of better days upon them, like a brand.

The bridge vaults may have been too damp for storage but now the area became a renowned red-light district, with brothels and pubs operating in the abandoned complex.

Conditions were appalling. The rooms were cramped, dark and damp. There was no sunlight, poorly circulated air, no running water, and no sanitation. Many rooms housed families of more than ten people and the vaults became a haunt of the criminal fraternity. Even after a rudimentary police force was established in Edinburgh, the Underground City continued to be a stronghold for villains. Burke and Hare, the infamous serial killers who sold corpses to medical schools, are said to have hunted for victims there, as well as in the local taverns.

In 1815, the *Edinburgh Evening Courant* reported that:

> On the 24th inst. Mr McKenzie, supervisor, accompanied by Mess. Gorie and McNaugton, officers, discovered a private distillery, of considerable extent, under the arch of the South Bridge, which has been working these 18 months past, to the great injury of the revenue. The particulars of this seizure are worthy of notice, from the great pains which had been taken to prevent disclosure. The original door to the place where the operations were going forward had been carefully built up and plastered over, so as to prevent any appearance of an entrance. Behind a grate in the fireplace of a bed-room, an opening had been made, and fitted with an iron door and lock, exactly fitting the grate, which could only be seen by being removed; and this passage led to the flat above by a trap-door and ladder, where the still was working. This place again was in one of the deaf arches, immediately adjoining the middle arch of the bridge, and the person had found means to convey a pipe from one of the town's branches, which gave a plentiful supply of water. A soil pipe was also got at, and a hole broke through into a neighbouring vent to carry off the smoke. Besides the still, a considerable quantity of wash, and some low wines, were found in the premises; also many casks, mash ton, large tubs, etc. The spirits were said to have been conveyed away in a tin case, made to contain two or three gallons, which was again put into a green bag, and carried out by a woman under her cloak.

The exact date when the vaults were closed down is unknown, as written records are virtually non-existent, but it took place between 1835 and 1875. The end, however, was swift, with tons of rubble dumped into the vaults to make them inaccessible. Then they were forgotten for almost a century.

The chambers were 'rediscovered' in the 1980s by former Scottish rugby internationalist Norrie Rowan, after he found a tunnel leading to them. Intrigued, he began to excavate.

He is also central to one of the great stories about the Underground City. And it's a doozie.

Weeks before the Romanian Revolution of 1989, the country's rugby team thrashed Scotland in an international match at Murrayfield. After the game, Romanian rugby player Cristian Raducanu was drinking in the Tron Bar, owned at the time by Rowan. Sensing what was coming back home, Raducanu let it be known that he wished to defect – a longing hampered by the fact that there were Securitate secret police guarding the exits. With Norrie Rowan's help, he entered a tunnel leading from the bar cellars into the bridge vaults and emerged several hundred yards away from the pub. He was then able to find a policeman and ask for political asylum.

Norrie Rowan continued to unearth the vaults, finding ancient artefacts including thousands of oyster shells – part of the staple diet of Edinburgh's working class.

Today, large parts of the South Bridge interior are accessible. Of course, the dark and creepy system lends itself to supernatural stories and the best way to see what is inside is a ghost tour. City of the Dead, Mercat and Auld Reekie Tours make nightly forays inside.

The vaults on the south side of the Cowgate arch form venues called The Caves and The Rowantree, which host private events, weddings, private dining, live music and the occasional club night. Within The Caves are the remains of what was Adam Square and Marlins Wynd (see Marlin's Wynd), demolished to make way for the erection of the South Bridge. The bridge vaults are also home to several pubs and nightclubs, like Whistle Binkies, Nichol Edwards and Bannermans.

https://unusualvenuesedinburgh.com/venues/marlins-wynd-venue-Edinburgh
https://www.cityofthedeadtours.com

South Bridge arch from the Cowgate.

FUN FACT

Robert Dundas, a wealthy judge from a prominent family, objected to the gradient of the proposed bridge, which would allow people to look into his windows. As a result, the bridge slopes down from the Tron Kirk and then up again, to the dismay of any horse-drawn vehicle. To make matters worse, Dundas died before the bridge was fully open.

Interest Rating 5/5

Haunted Rating 5/5

There are honestly too many alleged supernatural sightings to list, though favourites include The Watcher (a tall gentleman) and The Imp (who moves things around). Mercat Tours have had repeated reports of a character called 'Mr Boots', while City of the Dead Tours seems plagued by 'The South Bridge Entity'.

Left: South Niddry Street.

Above: City of the Dead Ghost Tour.

Below: South Niddry Street Vaults entrance.

Above and overleaf: South Bridge Vaults.

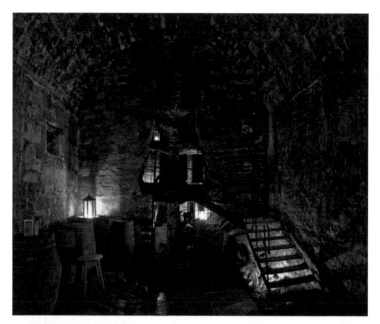

17

THE BEGINNING OF THE END

It was social reform, several particularly destructive fires, and a housing disaster that finally put an end to the Underground City and the slums of the Old Town. The first death knell came in 1824 with the Great Fire of Edinburgh. It wasn't the first giant conflagration to ravage the Old Town. There were massive blazes in 1544, 1676, 1700 and 1725. But the blaze of 1824 was on an unprecedented scale. It began in Old Assembly Close and spread to engulf the whole of the upper Royal Mile, from Parliament Square to Hunters Close. It raged with such fury that it took three days to extinguish and caused devastation to the packed wooden tenements lining the main thoroughfare. The sky-scraping buildings of Parliament Square were destroyed and even the mighty Tron Kirk succumbed, its great wooden spire eventually collapsing onto the street.

Unfortunate though the fire was, in many respects it marked the beginning of significant improvements in the Old Town. The first municipal fire brigade in Britain was founded by James Braidwood that same year, as a direct result of the disaster (he then went on to start the London Fire Brigade). Though the Grassmarket and Cowgate had not been touched, their demise as a slum dwelling was also a little closer.

Braidwood statue, Royal Mile.

Heave Awa' Close.

The second tragedy on the High Street occurred at Trotters House, a high tenement in what is now Paisley Close. The building had stood for 250 years but on 24 November 1861 it collapsed in the middle of the night, burying thirty-five people. Locals rushed from their houses and began to dig frantically through the rubble in a vain search for survivors.

From under a pile of beams, they heard the voice of a young boy. As they dug towards him, he shouted, 'Heave awa' lads, I'm no died yet.' They eventually pulled him out of the debris alive. Paisley Close is now usually called Heave Awa' Close and the boy's valiant words, along with a sculpture of his face, are carved above the entrance.

The collapse of Trotters House, like the Great Fire, heralded inevitable changes. This was mainly due to Humphrey Littlejohn, Commissioner of the Board of Supervision, which oversaw the city's sanitary conditions.

In 1865, he published his devastating *Report on the Sanitary Conditions of the City of Edinburgh*, which outlined deprivation and poverty in the Old Town. This led to almost two-thirds of the Royal Mile being demolished by 1900. The face of Edinburgh was changed forever.

FUN FACT
Littlejohn was cited by Arthur Conan Doyle as one of the inspirations for Sherlock Holmes.

18

RAILWAY MANIA

One of the strangest sections of underground Edinburgh can still partially be seen, and it was due to a phenomenon called 'Railway Mania'.

In the 1840s, existing railway companies' shares began to boom, as they moved ever-increasing amounts of cargo and people. Anyone could invest money (and hopefully earn a quick profit) in a new company and railways were heavily promoted as a foolproof venture. Thousands of investors on modest incomes bought huge numbers of shares, even though they were only able to afford the deposit. Families invested their entire savings in prospective rail companies, some of which mooted 'direct' railways, running in straight lines across swathes of countryside. These were promises that could never be kept, as such projects would have been nearly impossible to construct and totally unsuitable for the locomotives of the day to run on.

It was a pattern that had been seen before and since, usually with the same results. As the price of railway shares increased, speculators invested more money, further increasing the price of shares. Then the bubble burst, leaving thousands of businesses bankrupt and hundreds of routes unfinished.

Edinburgh was no exception, though it can't all be blamed on the share price bubble. As Scotland's road network expanded, some lines simply became unprofitable. But, because of Edinburgh's unique geography, they have left a fascinating legacy. And they're an extra treat if you're a railway buff.

The Scotland Street Tunnel

Of all the abandoned rail tunnels, this one is the most splendid. In August 1836, the Edinburgh, Leith & Newhaven Railway was given permission for a line running from Canal Street (now the site of Waverly Market, Princes Street) in the centre of Edinburgh to Trinity on the Firth of Forth. It was beset with problems from the beginning, due to financial difficulties and objections from residents. It was finally opened in 1842, linking Canonmills station (now Scotland Street) on the north side of the city centre to Newhaven station near Newhaven harbour, a popular location for early morning bathing.

In 1847 the line was extended southwards. This involved digging a gigantic tunnel from Canonmills, right under Canal Street, to a new terminus (now Waverley station) near the North Bridge. The original wagons had been horse-drawn but were replaced by locomotives.

The Scotland Street Tunnel is 1,000 yards long, 24 feet wide and 24 feet high, with a steep gradient of 1 in 27 towards the north. It was deep too, 49 feet under St Andrew Street

and 37 feet under Princes Street. In order to cope with the steep gradient, a stationary winding engine at Canal Street was constructed. Passenger carriages were steadied by brake trucks going down or hauled up by a rope, which ran under rollers beneath the rails.

This funicular must have been a truly impressive sight and Robert Louis Stephenson, always eager to portray the life of Edinburgh, wrote:

> The tunnel to the Scotland Street Station, the sight of the trains shooting out of its dark maw with the two guards upon the brake, the thought of its length and the many ponderous edifices and open thoroughfares above, were certainly of paramount impressiveness to a young mind. It was a subterranean passage, although of a larger bore than we were accustomed to in Ainsworth's novels and these two words, 'subterranean passage,' were in themselves an irresistible attraction and seemed to bring us nearer in spirit to the heroes we loved and the black rascals we secretly aspired to imitate.

The line regularly switched owners, ending up belonging to the North British Railway, but its days were numbered. In 1868 it was closed to passengers, ending up as a goods and coal depot.

In 1923, the North British Railway became part of the London & North Eastern Railway and the tunnel was closed. But that wasn't the end of its history.

During the Second World War, it became an air-raid shelter and the LNER emergency headquarters, housing a protected control centre with telephone links to all signal cabins, goods yards, major stations and offices. Scotland Street Yard continued to operate as a coal depot, which finally closed in 1967. In the 1970s, the tunnel was used for growing mushrooms (yes mushrooms) and Cochranes Garages Ltd leased the north end to store vehicles. It was also used as a location for monitoring natural radiation.

A number of schemes for using the tunnel have since been suggested, including a new emergency centre for Edinburgh City Council, the site of a giant boiler to generate power for the city centre, an underground car park and a new light railway or bus line. None have come to pass and the tunnel is still sealed by large iron gates. Little is left at either end to remember its glory days. The southern end was lost during the construction of Waverley Market, though there is still access and ventilation along a corrugated iron tube underneath. This runs to a gate in the wall, opposite platform 19 of Waverley station. Above the gate, the inscription 'Site of the original Edinburgh – Leith – Newhaven Railway' can be seen.

Scotland Street station goods yard is now a park with a playground, though the tunnel itself is still plainly visible. Inside, it is a melancholy place, damp and prone to flooding, with long stalactites hanging from the roof and calcium carbonate deposits covering the walls and floor.

FUN FACT
Alexander McCall Smith wrote a famous novel, *44 Scotland Street*, set right above the tunnel. There's no point in looking for it, though. The numbers end at 43.

Interest Rating 3/5 (5/5 if you can gain access).

South Entrance to Scotland Street Tunnel.

North Entrance to Scotland Street Tunnel.

No. 43 Scotland Street.

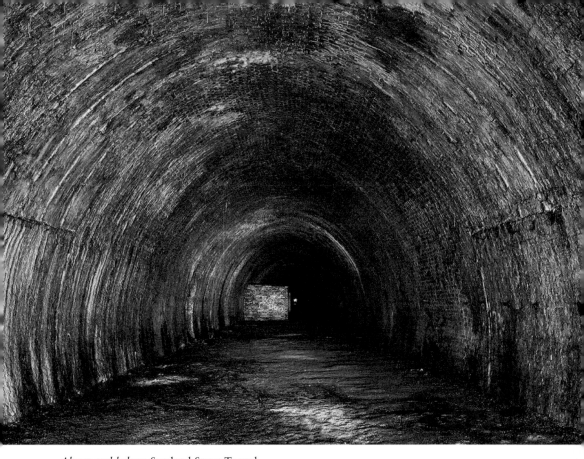

Above and below: Scotland Street Tunnel.

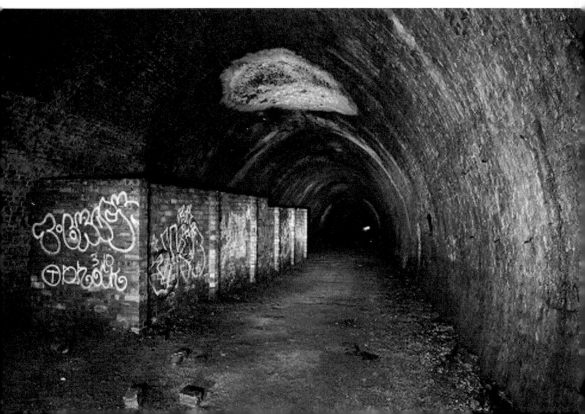

The Rodney Street Tunnel

A second shorter tunnel, on the north side of Canonmills, took the line under Rodney Street and Broughton Road. It is far less impressive than the Scotland Street Tunnel, only 179 yards long and was closed in 1967. The tunnel received a Grade B listing in 1974 and parts of it have been a foot and cycle path since 2009. The southern portal is at the opposite end of the same children's playground and another tunnel exists under East Trinity Road.

Interest Rating 2/5

Above and below: Rodney Street Tunnel.

The Calton Hill Tunnel

The Calton Hill Tunnel is actually twin tunnels, cutting through the southern edge of Calton Hill, east of Waverley station. This is where the lines east from Waverley leave the city centre, with a 1 in 78 gradient – the steepest part of the East Coast Main Line from Edinburgh to Kings Cross. Built in 1846 by the North British Railway Company, the original tunnel was 1,203 feet long. It was fitted with large ventilation shafts, occasionally stumbled upon when excavation or development work is done in the area – and often mistaken for underground streets. Though there are buried dwellings around nearby Regent, Bridge, the tunnel was never occupied by anything but trains.

The west end was remodelled and a second tunnel built in 1902, 1,431 feet in length. If you stand on North Bridge, you can look across to the entrances, under the former Calton Jail.

FUN FACT
In 1940, Edinburgh stained-glass artist James Ballantine (1878–1940) was killed after falling from a moving train in the tunnel. Actually, that's not so much fun when you think about it.

Interest Rating 3/5 (Warning: do not attempt to go into these tunnels, or you will be hit by a locomotive).

Below and overleaf above: Calton Hill Tunnel.

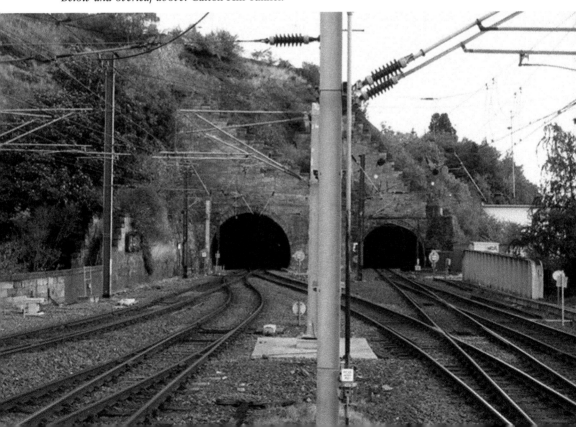

The Innocent Railway

Next to Holyrood Park, near the foot of Arthur's Seat, is a pathway that runs partially underground. It was Edinburgh's first railway line, horse-drawn trams bringing coal to the city from the Dalkeith mines, further south. In 1832 it switched to horse-drawn passenger carriages, then steam trains in 1845.

A plaque at the entrance ascribes the name 'Innocent Railway'. Some say it came from the horse-drawn trams being safer and less sophisticated than the engines that came later. Other sources attribute the name to the fact that there were no casualties while building the railway – a rare occurrence in those days.

It was the first underground railway passage in the United Kingdom, stretching for an estimated 9 miles.

The line ceased operation in 1963 and, in 1981, was reopened as a pedestrian and cycle path, part of the UK National Cycle Network's Route 1. The picturesque trail winds past the bird sanctuary of Duddingston Loch, near Duddingston Village, before continuing southward. The tunnel section has an entrance that is particularly difficult to find, tucked away in a small housing complex opposite Pollock Halls, near the entrance of Holyrood Park. I'm not going to spoil the excitement of locating it by including a picture.

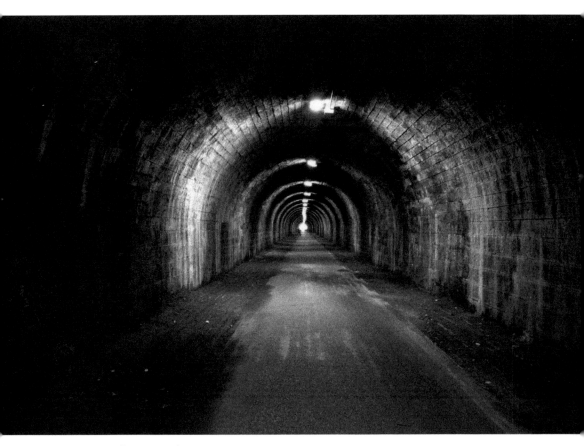

Innocent Railway Tunnel.

FUN FACT
The Innocent tunnel has a rather unnerving optical illusion. As you cycle along, the exit doesn't seem to get any nearer. Then, suddenly, you are at the end. It's pretty cool and I recommend you try it.

Interest Rating 3/5

19

GILMERTON COVE

Gilmerton Cove is one of the true underground oddities in Edinburgh. It lies under the former mining village of Gilmerton, now a city suburb.

Until the twentieth century, the traditional explanation of its existence wasn't questioned. In 1720, the soft and workable nature of the sandstone at Gilmerton tempted a blacksmith named George Paterson to construct a cave in the garden at the end of his house. Between 1720 and 1724, he dug out a dwelling consisting of a 45-foot corridor, with rooms off either side. These included a smithy with a forge; a dining-room furnished with a stone bench, table and bed recess, a drinking parlour; a kitchen and bed-place and a cellar, chapel and washing-house.

Over the entrance was an inscription by Alexander Pennicuik, 'the burgess-bard of Edinburgh'.

Here is a house and shop hewn in this rock with my own hand. -GEORGE PATERSON.
Upon the earth there's villany and woe,
But happiness and I do dwell below;
My hands hewed out this rock into a cell,
Wherein from din of life I safely dwell:
On Jacob's pillow nightly lies my head,
My house when living and my grave when dead:
Inscribe upon it, when I'm dead and gone,
I lived and died within my mother's womb.

Paterson lived there for eleven years. He was visited regularly by holiday parties and court judges drank in his stone parlour. In appreciation of this momentous undertaking, he didn't have to pay any taxes so, apparently, there was method in his madness.

It was described by Revd Thomas Whyte, the parish minister of Liberton, in 1792.

Here is a famous cave dug out of rock by one George Paterson, a smith. It was finished in 1724 after five years hard labour as appears from the inscription on one of the chimney-heads. In this cave are several apartments, several beds, a spacious table with a large punch-bowl all cut out of the rock in the nicest manner. Here there was a forge with a well and washing-house. Here there were several windows which communicated light from above. The author of this extraordinary piece of workmanship after he had finished it, lived in it for a long time with his wife and family and prosecuted his business as a smith. He died in it about the year 1735.

But is that really the case? Typical for Edinburgh, nothing is as it seems.

It seems highly unlikely that one man could dig out this truly impressive structure in five short years. The cave was investigated in 1897 by F. R. Coles, assistant keeper of the National Museum of Antiquities in Scotland, who cast grave doubt over whether Paterson had been responsible. He found that 'the method of cutting stone pointed to an origin much more remote than the 18th century and the substantial work involved in excavating the cave could not have been carried out by one man'.

It would make more sense if he found it. Which begs the question, what exactly was Gilmerton Cave and why was it built?

The origins of the hand-carved tunnels, which are certainly at least 300 years old, remain a mystery – though conflicting theories abound. It has been claimed it was a drinking den for eighteenth-century gentry, a lair inhabited by Knights Templar or a refuge for seventeenth-century Covenanters fleeing persecution. In 2007, the documentary television series *Cities of the Underworld* suggested the Cove was linked to a nearby Hellfire Club building via a secret passage.

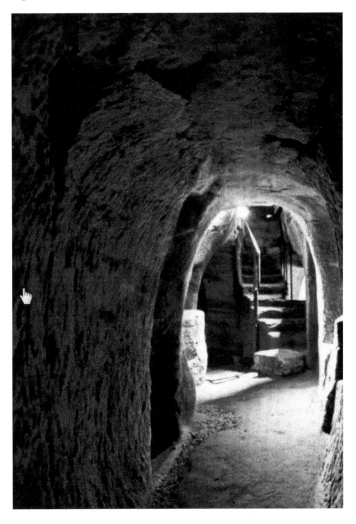

Right and overleaf:
Gilmerton Cove.

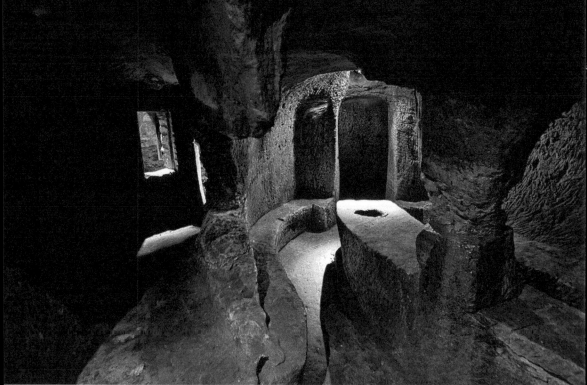

Some of the passages end abruptly and it would seem the cove is much bigger than it appears. Scientists from the universities of St Andrews and Edinburgh used ground-penetrating radar equipment to map out what else may lie beneath, discovering the subterranean network was at least double the size originally thought. According to Simon Shackley, from Edinburgh University's School of Geosciences:

> On the other side of Gilmerton Road there is a rather large chamber that is probably about four meters deep. There also appear to be cavities in front of the cove and behind it – both about ten meters deep.

I think a vital clue lies in what is outside. Gilmerton is high up and, though there are now buildings in the way, it once afforded a view right across Edinburgh to the castle. In other words, it was easy to spot people coming – be they soldiers or other authority figures. It's a fair bet that, whatever was going on in Gilmerton, this superb vantage point gave the culprits plenty of warning of approaching danger and a great place to hide. So my money is on seventeenth-century Covenanters holding Conventicles (illegal prayer meetings).

20

ROSSLYN CHAPEL

Strictly speaking, Rosslyn Chapel is in the village of Roslin but it's on the fringes of Edinburgh, less than 7 miles from the city centre, so I figure it counts. I'm not missing out something with such a fantastic history.

The Collegiate Church of St Matthew (or Rosslyn Chapel) is a Scottish Episcopal Church, begun in 1446 by William St Clair, third Prince of Orkney, who is buried there. And it's an architectural masterpiece.

The building we see today is much larger than the original and it has been attacked more than once. In 1688 an angry Protestant mob from Edinburgh caused so much damage, it was abandoned until 1736, when James St Clair began repair and restoration.

The inside boggles the mind, filled with ancient, intricate symbolic carvings. Because this is a book about things underground, I won't go into too much detail about the chapel itself, but a couple of things have to be included. One is the idea that Sir William's grandfather, Henry Sinclair, led a 1398 expedition to what is now Massachusetts, 100 years before Columbus reached the West Indies. Evidence of this is found in carvings of what can only be described as maize – not found anywhere in Europe at the time. Many scholars have refused to accept these images could possibly represent American vegetation, and must be stylised versions of native fauna. But I've seen them and they sure look like maize to me.

What of the underground connection, I hear you cry? Well, Rosslyn Chapel has a huge connection with the Knights Templar, leading to another of Edinburgh's most famous subterranean stories.

Despite their mythological reputation, the Order of the Knight's Templars had very practical origins. They were a European monastic military order, formed around the twelfth century, protecting pilgrim routes to the Holy Land. During the early Crusades, they distinguished themselves as a formidable Christian fighting force, and their merciless slaughter of the Muslim enemy was particularly appreciated by Crusaders.

As the Templar's reputation grew, so did their size and power. Within two centuries, they had become a religious Frankenstein's monster. Famed for the incredible wealth they amassed during the Crusades, rather than for piety or skills in war, they are credited with the invention of banking in Europe. Though lending money was forbidden by the Church of Rome, the Templars were powerful enough to circumvent this, providing under-the-round-table financing for kings and major nobles.

The Knights drifted from their original goal as defenders of Christianity and settled into the role of medieval powerbrokers. That power was a threat to the established order in Europe – monarchies didn't like being in hock and the Papacy wasn't used to being defied. So they began plotting to cut the Templars down to size.

People didn't do things by halves in the Middle Ages. In 1308 Philip of France arrested Jacques de Molay (*c.* 1245–1314), the Grand Master of the Knights Templar, and, four years later, a Papal decree dissolved the Order entirely.

The assault on the Knights Templar was as swift and ruthless as any they had conducted against the Muslims. The Order was accused, en masse, of heresy and its members found themselves persecuted across Europe. Their vast assets were seized by the financially strapped Philip of France, which gives another clue as to his reasons for wanting them out of the way.

Heresy was a pretty serious charge in fourteenth-century Europe and, besides, nobody would support the Templars against the combined might of the Roman Catholic Church and the Kingdom of France. The hapless Knights found themselves without allies and no country was willing to give them protection.

With one exception. In Scotland, no order of suppression had been issued against the Templars since, under Scots law, charges against the Order had been found 'Not Proven'. This didn't mean much to the European powers, who were determined to have the Templars stamped out. Any king seen to be giving them shelter was liable to be excommunicated by the Pope, as well as incurring the wrath of Philip of France.

These deterrents did not hold much weight in Scotland. In the early fourteenth century, the king was Robert the Bruce, and he had already been excommunicated. Bruce also

Rosslyn Chapel.

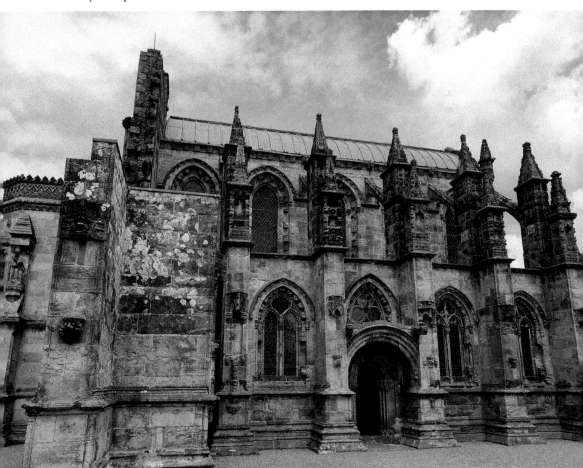

Rosslyn Vaults.

happened to be waging a campaign against Edward I of England, Philip's hated enemy. France was certainly not going to penalise such a valuable ally.

Shunned by the countries they had once protected and with no chance of migrating east to non-Christian lands, many of the Knights Templar fled to Scotland. And Roslin became their most famous stronghold.

If you enter the chapel, you'll find steps leading down into vaults. Once again, because of the topography, they are under the chapel but above ground on one side. Yet, legend says there is a much deeper vault and, in it, the Templars hid the Holy Grail, which they had spirited away from Jerusalem. Other theories of what is hidden below include the skull of John the Baptist, the embalmed head of Jesus, sacred scrolls from the time of Christ, a fragment of the cross on which he died, the final resting place of Mary Magdalene's bones and a dozen armed Knights Templar. If any of these are true, this truly would be the Holy Grail of underground finds (excuse the pun). There are supposed to be symbolic clues in the celling's carvings, though nobody has worked them out yet. Feel free to have a go.

One conjecture is actually quite feasible. That ancient books were rescued from a fire at nearby Rosslyn Castle in 1452 and stored under the chapel. Rosslyn Castle, now a ruin, was a scriptorium where friars wrote manuscripts and is thought to have been connected to the chapel by tunnels.

True or not, these imaginings were massively fuelled by Dan Brown's *The Da Vinci Code* but modern technology has shown that there do seem to be sealed vaults under the chapel. So you never know.

https://www.rosslynchapel.com

FUN FACT
Rosslyn Chapel holds the highest number of pagan 'Green Man' images of any European medieval chapel.

Interest Rating 4/5 (5/5 if the hidden vault is ever opened).

Haunted Rating 4/5
Allegedly, an apprentice mason carved the extraordinary 'Apprentice Pillar' while the master mason was in Italy. Consumed with envy when he returned, he murdered the apprentice and the young man now haunts the chapel. It is also haunted by one Lady Bothwell, the Mauthe Hound and the Black Canons (priests, not guns).

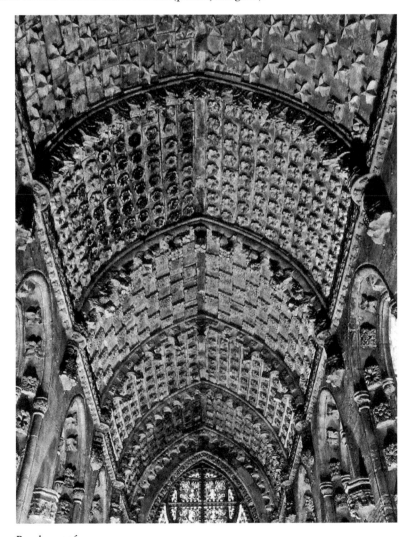

Rosslyn roof.

CONCLUSION

'Edinburgh isn't so much a city, more a way of life... I doubt I'll ever tire of exploring Edinburgh, on foot or in print.'

Ian Rankin

It's true that what is out of sight can very easily be put out of mind, and Edinburgh's underground has passed from the realm of fact and into fable.

People still whisper of underground tunnels running under all of the city, not just the Old Town, and this is true to some extent. Apart from the legendary castle tunnels there are, for example, sewage tunnels under Princes Street, but this occurs in most cities.

I've presented the evidence and will leave it to you to decide whether Edinburgh really has an Underground City, or if it ever did.

If so, it's a conglomeration of many things. A skeleton fleshed out by generations of weird and wonderful stories. Tiny fragments of what is, and might be, join together to form a mythical picture.

Certainly, some may simply be fables, like the castle tunnel. Yet, there were plenty of wonders under the streets of the capital, no denying that, though much has been lost forever. The original tenements of the High Street, Cowgate and Grassmarket are mostly destroyed and any vaults that haven't been filled in are plain old cellars again, belonging to the houses and shops above. There is scant surface evidence of the past horrors of living below ground but we do know it happened. Other sections may be closed to the public, like upper Marlin's Wynd, but are still there. The fragments we can still see are truly impressive, like Mary King's Close or the South Bridge.

And there is still plenty left to discover under Edinburgh, popping up in the oddest of places.

In 2019, the construction of the first Virgin Hotel in Britain in the Cowgate/Grassmarket area was delayed for a year after archaeologists unearthed artefacts dating back 1,000 years to the tenth century. Some of the finds may even date as far back as the Bronze Age.

Experts say the remains of buildings found predate Edinburgh Castle, and the creation of the town burgh by David I, by around 200 years. These included ditches and walls marking the original boundary of the city, hearths, wall panels, structural timbers, rubbish pits, wells, a human skull, drinking vessel, shoes, jewellery, and knives – along with a ball used in a giant catapult and an early cannonball.

It is one of the most significant urban excavations ever undertaken in Scotland and, according to archaeologist John Lawson, 'There are a great sequence of layers on the site which almost tell the story of Edinburgh in microcosm.'

As usual, it hasn't stopped the hotel getting built, even though nineteen notable writers, artists and academics wrote a letter to *The Times*, denouncing the enterprise as asset stripping. Sometimes city authorities are their own worst enemy.

Edinburgh's Underground City is a changing landscape. The top of Marlin's Wynd was there for all to see and now it isn't. We can only hope Edinburgh Council will come to their senses and open it again. The South Bridge Vaults, forgotten for 100 years, are now a massive visitor attraction. There's no reason why the Scotland Street Tunnel could not serve the same purpose.

And you never know, perhaps that secret passage under Edinburgh Castle will be discovered again. Then you can sneak into the place for free.

Whatever transpires in the future, there is still enough for you to look around and judge for yourselves.

Happy hunting.

SELECT BIBLIOGRAPHY

Ainslie, John, *City of Edinburgh* (1780)

Arnot, Hugo, *The History of Edinburgh* (West Port Books)

Bell, George MD, *Blackfriars Wynd Analysed*

Birrell, J. F., *An Edinburgh Alphabet* (The Mercat Press, 1980)

Books of the Old Edinburgh Club (Vols I to present)

Buchanan, George, *The History of Scotland* (Churchill, 1690)

Chambers, Robert, *Traditions of Edinburgh* (London, 1824)

Colvin, Howard, *A Biographical Dictionary of British Architects 1600–1840* (Yale University Press, 1995)

Daiches, David, *Edinburgh*, (Hamish Hamilton, 1978)

Dick, William, *From Castle To Abbey* (Scottish Automatic Printing)

Donaldson, Gordon, *Scottish Kings* (London, 1967)

Fife, Malcolm, *The Nor Loch* (Edinburgh: Pentland Press, 2001)

Gifford, John, McWilliam, Colin, and Walker, David, *The Buildings of Scotland* (Edinburgh: Penguin Books, 1984)

Gilbert, W. M., *Edinburgh in the Nineteenth Century* (Edinburgh, 1901)

Grant, James, *Cassell's Old and New Edinburgh* (London: New York: Cassell, Petter, Galpin & Co., 1881)

Hanney, R, K, and Watson, G., *The Building of Parliament House*

Henderson, Jan-Andrew, *Edinburgh: City of the Dead* (Edinburgh: Black and White, 2004)

Henderson, Jan-Andrew, *The Emperor's New Kilt* (Edinburgh: Mainstream, 2000)

Henderson, Jan-Andrew, *The Ghost That Haunted Itself* (Edinburgh: Mainstream, 2001)

Henderson, Jan-Andrew, *The Town Below the Ground* (Edinburgh: Mainstream, 1999)

Keay, John and Julia (Eds), *The Collins Encyclopaedia of Scotland* (Harper Collins, 1994)

Keir, David, *The City of Edinburgh, The Third Statistical Account of Scotland*

Kenyon, John Philipps, *The Stuarts: A Study in Kinship* (Fontana Press, 1970)

Littlejohn, Henry, *Report on the Sanitary Condition of the City of Edinburgh* (Edinburgh, 1863)

Lochhead, Marion, *Edinburgh Lore and Legend* (St Edmundsbury Press, 1986)

Macleod, Ed W., and Wood, M., *Protocol books of John Fowler (1501–28)* (Scottish Record Society)

Maitland, W, *A History of Edinburgh*

Masson, D. (ed), *Register of the Privy Council of Scotland* (Edinburgh, 1882)

Minto, C. S., *Edinburgh, Past and Present* (Oxford Illustrated Press, 1975)

Reed, A. H., *The Story of Early Dunedin* (Wellington, 1956)

Ross, Stewart, *Monarchs of Scotland* (Lochar Publishing, 1990)

Royle, Trevor, *Precipitous City* (Edinburgh: Mainstream Publishers, 1980)

Sinclair, George, *Satan's Invisible World Discovered* (Edinburgh, 1685)

Skinner, Robert, *The Royal Mile* (Edinburgh: Oliver and Boyd, 1947)

Smith, Mrs J. Stewart, *Historic Stories of Bygone Edinburgh* (T&A Constable Ltd, 1924)

Stevenson, Robert Louis, *Picturesque Old Edinburgh (*Albyn Press, 1983)

Underwood, Peter, *Gazetteer of Scottish Ghosts* (London, 1974)

Watt, Francis, *The Book of Edinburgh Anecdotes* (London, 1913)

Wills, Elspeth, *Scottish Firsts* (Glasgow: Scottish Development Agency, 1985)

Wood, Margaret, *Edinburgh 1329–1929*

Wood, Margaret, *Survey of the Development of Edinburgh*

Additional info by the Real Mary King's Close and City of the Dead Tours.

ABOUT THE AUTHOR

Jan-Andrew Henderson is the author of thirty-seven teen, YA and adult thrillers and non-fiction books. He has been published in the UK, USA, Canada, Australia and Europe by Oxford University Press, Collins, Hardcourt Press, Amberley Publishing, Oetinger Publishing, Mainstream Books, Black and White Publishers, Mlada Fontana, Black Hart and Floris Books. He has been shortlisted for thirteen literary awards in the UK and Australia and is the winner of the Doncaster Book Prize, the Aurealis Award and the Royal Mail Award.

www.janandrewhenderson.com